C000296137

LONDON'S DOCKLANDS
THROUGH TIME
Michael Foley

AMBERLEY PUBLISHING

To our lovely little Amelia

First published 2014

Amberley Publishing
The Hill, Stroud, Gloucestershire, GL5 4EP
www.amberley-books.com

Copyright © Michael Foley, 2014

The right of Michael Foley to be identified as the
Author of this work has been asserted in accordance
with the Copyrights, Designs and Patents Act 1988.

ISBN 978 1 4456 4049 5 (print)
ISBN 978 1 4456 4082 2 (ebook)

British Library Cataloguing in Publication Data.
A catalogue record for this book is available from
the British Library.

Typesetting by Amberley Publishing.
Printed in the UK.

Introduction

Mention London's Docklands to anyone today and they will immediately think of the amazing new buildings that have taken the place of the small houses where the dockers lived and the old warehouses that were once filled with goods from all over the world. The reality is quite different. The area that has been redeveloped, and that is now covered in large modern buildings, is mainly concentrated on the Isle of Dogs on the north bank of the river.

There are other parts of the old docklands that have hardly changed at all. Even close to the centre of London, just below Tower Bridge, many of the old warehouses have survived in their almost-original state, with narrow streets between high buildings and walkways joining the buildings above the heads of those walking below. The use of these buildings has changed, of course; most of them are now expensive apartments close to the river.

Further downstream, especially to the south of the river, there has been little change in hundreds of years. Greenwich, with its strong naval connections, is still the site of numerous grand buildings that have stood overlooking the river since Nelson's ships sailed up to Greenwich Pier. The patients from the Royal Naval Hospital were so numerous that when Queen Caroline arrived there in 1795 she asked if all Englishmen had an arm or a leg missing.

Further downriver at Woolwich, it was the Army that dominated the banks of the river. As well as a number of large barracks for the troops, there was the Woolwich Arsenal which produced much of the country's armaments for many of the wars that were fought around the world. The arsenal buildings still survive, as does some of the barrack. Again, not all of them are now being used for what they were built for.

As well as being the site of the world's busiest docks, the banks of the Thames below London were also a major ship-building site. The early wooden ships of medieval days and many of the first ironclad

battleships of the British and other navies were built in the shipyards of the Thames and Bow Creek, including a number that took part in the First World War.

Where ships from all parts of the world arrived and left for distant shores, there currently stands an airport, and it is now aircraft that comes and goes. The airport and the rest of the docklands are now served by a modern railway whose trains give a wonderful view of both the old and new parts of the docklands.

An unintended lasting result from the men who worked in the docklands in the past came from their leisure activities. The football team, Woolwich Arsenal, may have moved to North London, but the gun on the club badge show its origins. The Thames Ironworks, who built ships on Bow Creek, also had a team that outlived its parent company. The crossed hammers on the badge of West Ham United show its docklands origins.

Millwall were another team with connections to the shipbuilding industry. The rivalry that existed between the two shipbuilding communities was reinforced when the mainly dock working supporters of West Ham United staged a dock strike in 1926. The dockers of Millwall did not. The bitterness from that time exists up to the present day, with sporadic outbreaks of violence occurring when the two teams meet.

The banks of the river below London have changed in many ways since the docks began to close in the middle of the last century. It still presents as an amazing place, with a long history that continues to affect many aspects of life for those whose family history is rooted in the area.

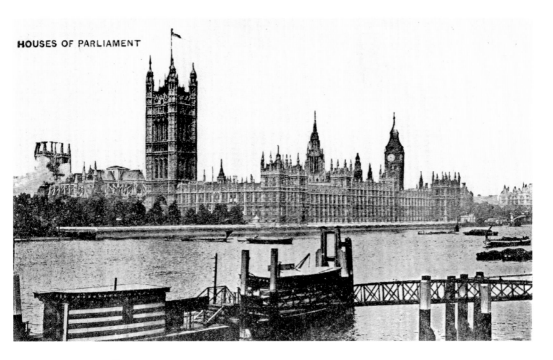

Barges at Parliament

London's Docklands are mainly thought to have been situated in the east end of the city below Tower Bridge. In fact, large ships could reach as far as London Bridge due to Tower Bridge being able to be raised. Beyond this, goods were often transferred to barges that could be towed upriver by tugs (as seen in the older image) with a number of barges in the river in front of Parliament. The modern image shows that it is now pleasure craft that reach this far upriver.

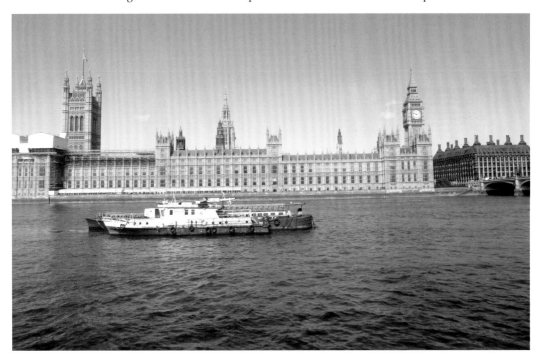

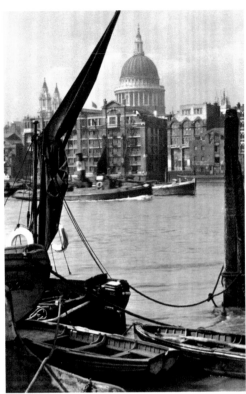

Barges at St Paul's

The river below St Paul's is also crowded with barges, shown in the old image above taken about a century ago. It is mainly pleasure boats that sail this far upriver today as the cargo-carrying barges have disappeared from the river in central London. The pleasure craft carry sightseers to the attractions of London from the river. There has also been a change in the buildings lining the bank in front of St Paul's.

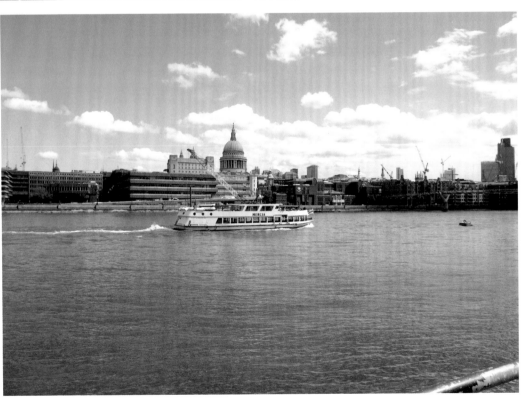

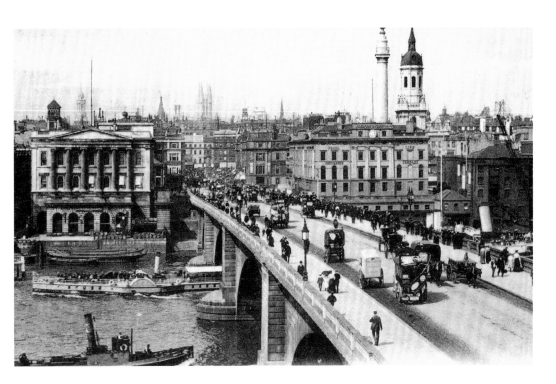

London Bridge

The larger cargo-carrying vessels that travelled upriver could reach no further than London Bridge as they were unable to pass beneath its low arches. As the old image shows, tugs and pleasure craft, such as the old paddle steamers, could pass underneath the bridge to reach the upper reaches of the river. The bridge itself has of course changed in the period between the two images.

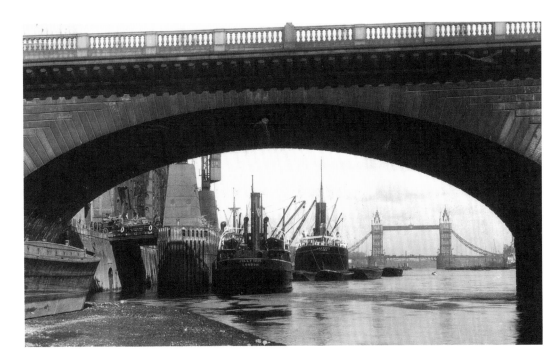

London Bridge

A wonderful view beneath one of the arches of old London Bridge that shows the busy Pool of London between London and Tower Bridges. In the past, the area between the two bridges was one of the busiest on the river with a large number of ships moored at the crowded banks. The older image shows the previous London Bridge, which was famously sold to America when it was dismantled. The modern bridge that replaced it opened in 1973.

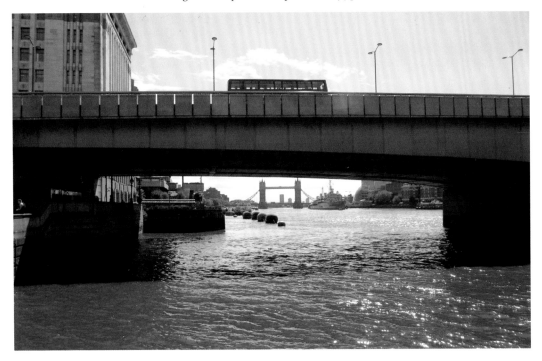

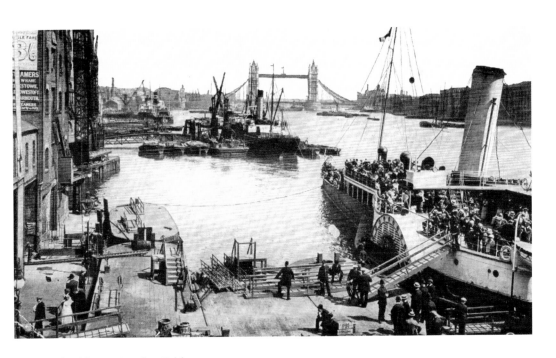

Embarking at London Bridge

It was not only goods that were unloaded at London Bridge. The paddle steamers of the past, which regularly travelled up and down the river carrying passengers, also stopped at the bridge. The steamers would carry Londoners down to the coast at places such as Southend, Clacton, and the pleasure gardens at Gravesend. A trip on a steamer was often the only holiday working people would get. The modern image shows that the site is still busy with pleasure craft, although these are unlikely to go as far downriver as they did in the past.

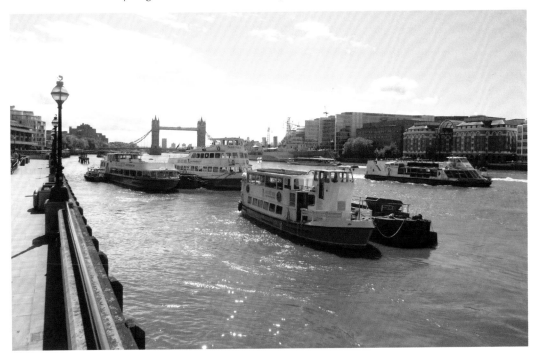

9

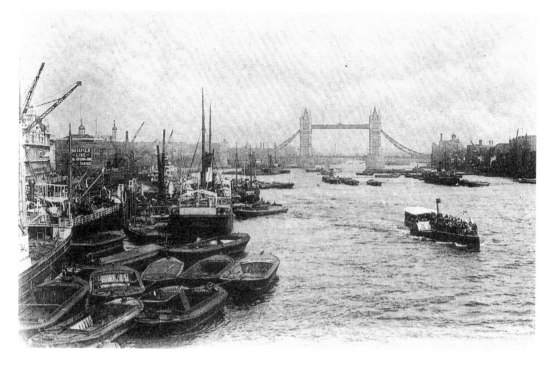

Pool of London

There are perhaps almost as many vessels using the Pool of London today as there were in the past when the docks were open, but they are much smaller than they used to be. The buildings lining the banks have also changed dramatically, such as the new offices of the London Mayor visible in the centre of the modern image.

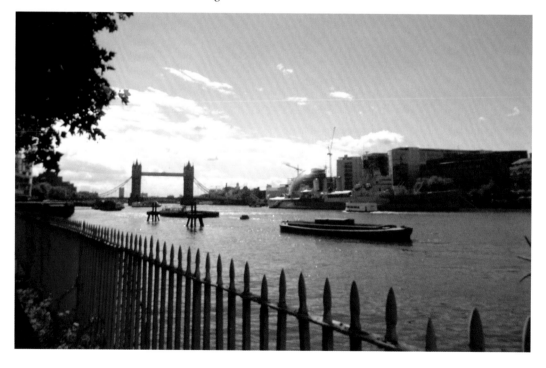

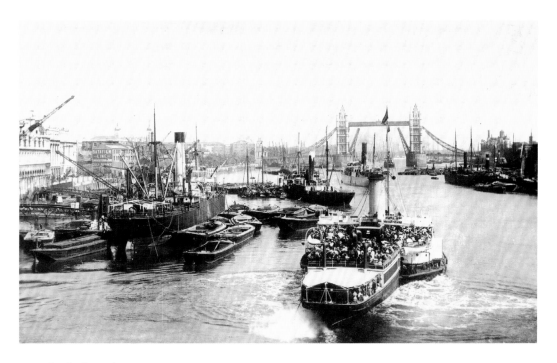

Pool of London

The old image from the First World War period shows how busy the Pool of London was when the London Docks were open. The area was often crowded with large ships and barges. Today, the largest ship in the pool is HMS *Belfast*, which is now a floating museum. The banks of the river are also now overlooked by a number of new and very tall buildings such as the Shard, one of the largest in the world, shown in the modern image.

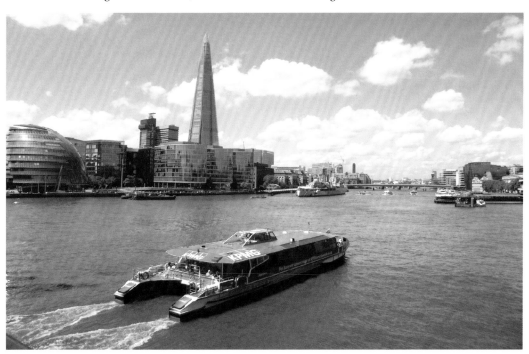

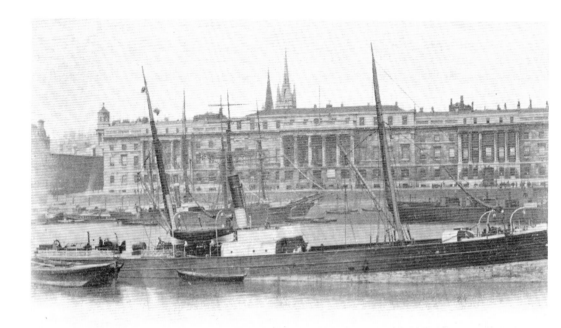

London's Custom House

There was a Custom House near the present building during the Middle Ages that was destroyed during the Great Fire of London in 1666 along with other buildings that stood on the river bank. A new building, designed by Christopher Wren, replaced this and was also destroyed by fire in 1715. The present building on the north bank of the river, east of London Bridge, was started in 1813. It is now used by Her Majesties Revenue and Customs.

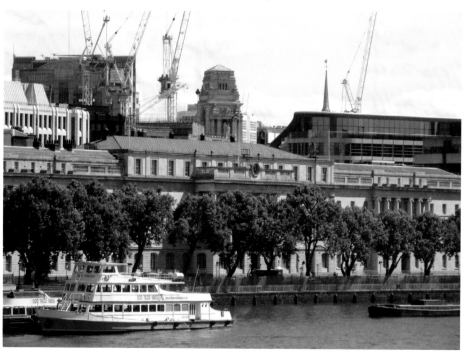

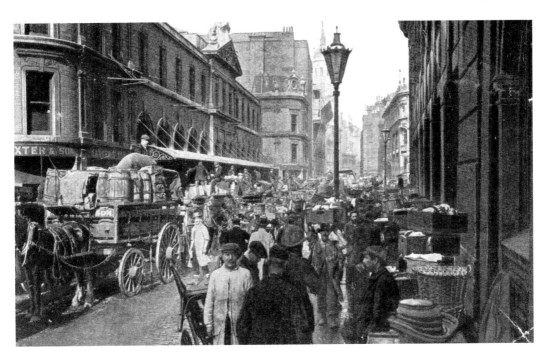

Billingsgate Market

There has been a fish market at Billingsgate since the sixteenth century. The present building was opened in 1877. Although the fish used to arrive from the river, by the late nineteenth century much of it arrived by train, which meant that the market no longer needed to be on the bank of the Thames. The market moved to a new building on the Isle of Dogs in 1982. The old Billingsgate building is now a restaurant and conference centre.

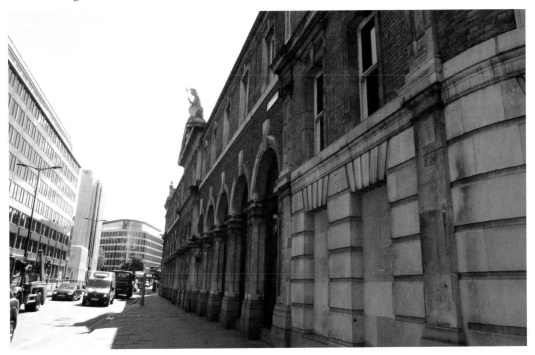

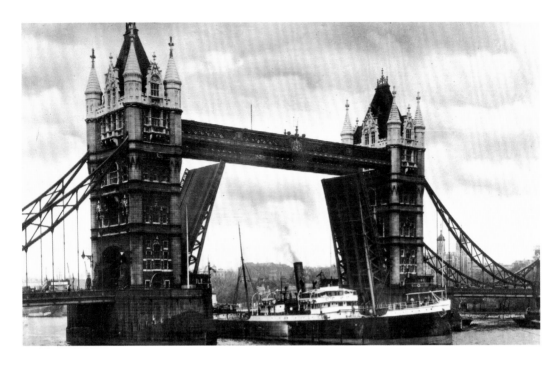

Tower Bridge

A new bridge was needed in the mid-nineteenth century downriver of London Bridge due to increased commercial activity in the east end of London. A traditional bridge would have restricted the movement of large ships into the Pool of London, so a public competition was commissioned for the design of the new bridge. The winner was Sir Horace Jones, who was also one of the judges. Tower Bridge opened in 1894 and can be raised to allow the passage of large craft as the old image shows. It is raised much less frequently than it was in the past.

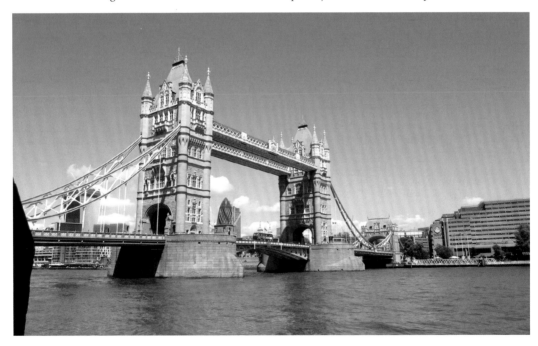

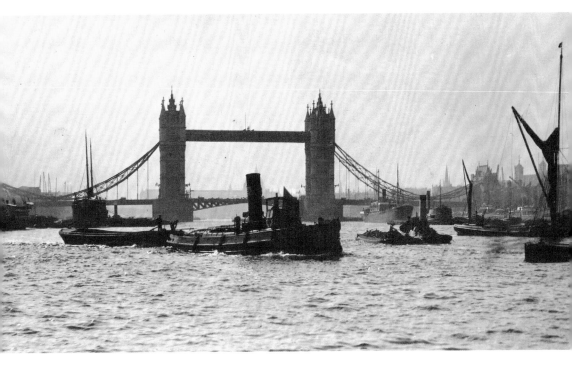

Below Tower Bridge

The area below Tower Bridge was almost as busy as the Pool of London when the docks were open. The old image shows many ships, barges and tugs on the river. As well as the volume of traffic, the buildings on the bank have also changed, as shown in the modern image with the Tower Hotel to the right of the bridge and the new buildings behind the tower, such as the Gherkin.

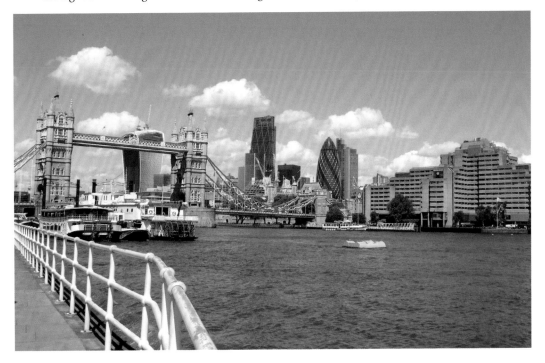

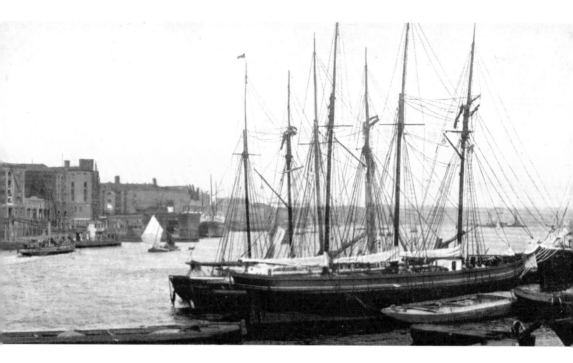

Bermondsey

Bermondsey was a notorious slum area in the mid-nineteenth century and was used by Charles Dickens as the scene for some of his books. The coming of the docks in the late part of the century led to widespread redevelopment, with a large number of warehouses being built along the south bank of the river. This had the added advantage of clearing the worst of the slums as well as providing work. The view across the river from Bermondsey to the north bank has changed little between the two images, although the use of the building lining the bank has.

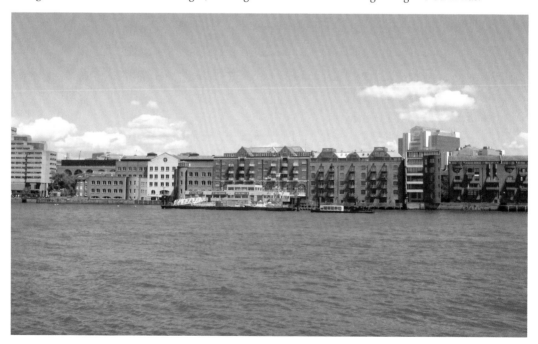

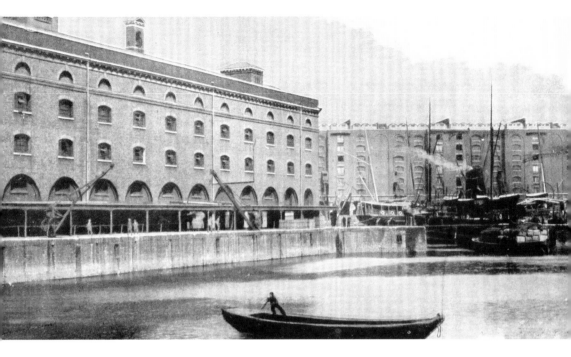

St Katherine's Dock

St Katherine's Dock was named after a hospital of the same name that stood on the site in the twelfth century. When the dock was built in the early nineteenth century, over a thousand houses were demolished, which, like those across the river at Bermondsey, were slums. The dock opened in 1828 but was never able to take large ships, and was as a result, was the first of the docks to close in 1968. The Tower Hotel, office and apartments were built on the site of the warehouses that were demolished, but some original buildings remain.

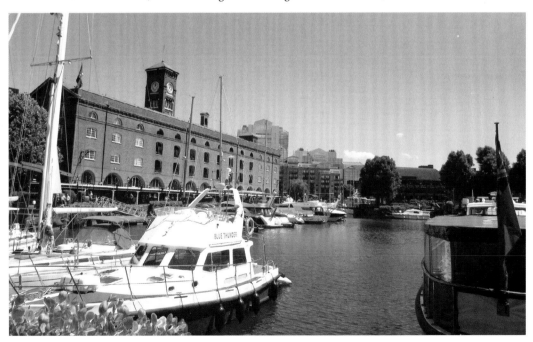

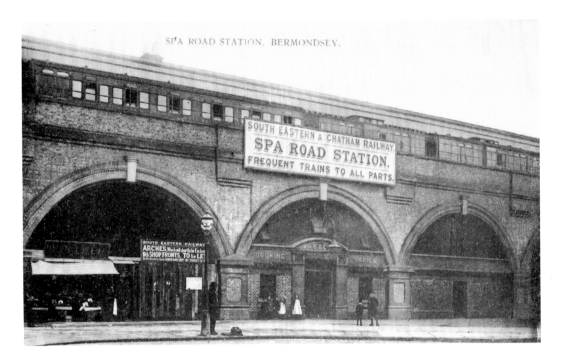

Spa Road Station

Spa Road railway station is in Bermondsey and was part of the London to Greenwich Railway; the first passenger railway line to open in London. The first part to open was the Spa Road to Deptford High Street line. The site of the station, now closed, has a large image of it on the wall in the underpass, shown in the new image. There are similar memorials to other parts of the line in the area. Much of the industry in the area consists of small business based in the railway arches of the old line.

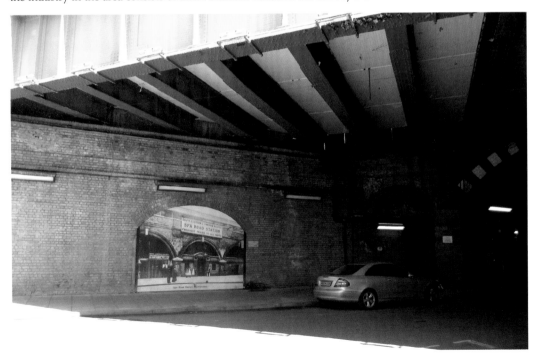

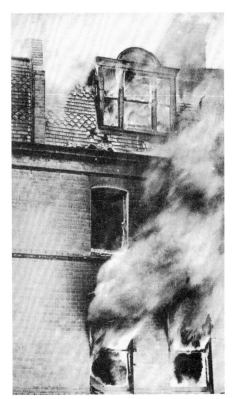

Battle of Sidney Street

The docklands area has always been the site of settlement of a number of waves of immigrants. In the early twentieth century, a number of anarchists from various parts of Europe settled in the area around Whitechapel. They funded their organisations with robberies and, in December 1910, two police officers were shot and killed during a robbery at a jeweller's in nearby Houndsditch. Members of the gang were later traced to a house in Sidney Street near Whitechapel station.

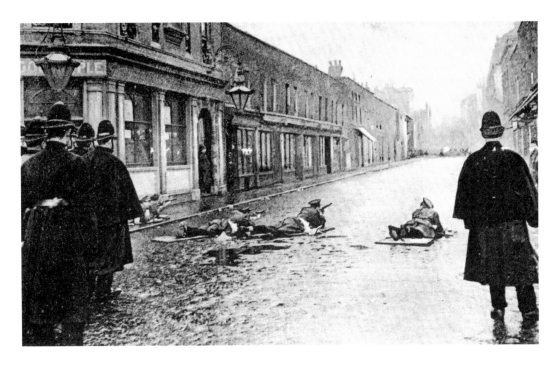

Battle of Sidney Street

When the police arrived at the house in Sidney Street where the leader of the anarchist gang involved in the Houndsditch robbery, Peter the Painter, was supposed to be, they were fired upon. Despite there being 200 police officers present at siege, the then Home Secretary, Winston Churchill, arrived and called in the Scots Guards from the Tower of London with a field gun. He refused to let the fire brigade enter the house when it caught fire. Most of Sidney Street has now been redeveloped, although there are some older buildings near Sidney Square.

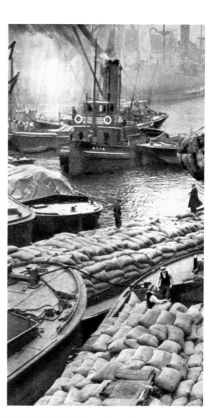

Barges Full of Goods from the Ships

Many of the goods from the large ships were loaded into barges that could then be taken to places less accessible to the large ships. The modern image shows the river looking towards Shadwell. The dock at Shadwell was known as the basin. The south basin was built in the 1830s and the north in the 1850s. As with some other docks, they replaced areas of slum dwellings. The modern image shows the apartments that have now been built along the bank of the river.

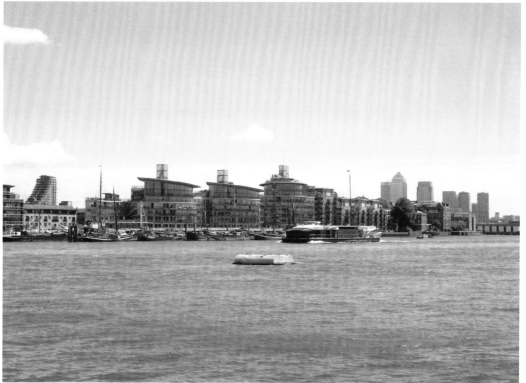

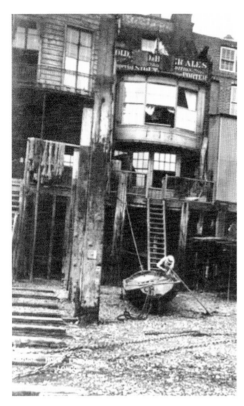

The Grapes Public House at Limehouse

The Grapes public house dates back more than 500 years and still stands on the river in Narrow Street, Limehouse, which was at the centre of the old docks. Sir Walter Raleigh set sail on his third voyage to the New World from the river by the Grapes. The inn was also used as a scene, although disguised, by Charles Dickens in his book *Our Mutual Friend*.

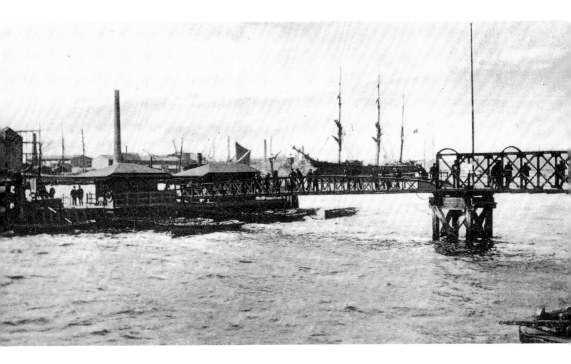

Limehouse Pier

There have been at least three piers at Limehouse. One was built in 1843 to enable the area to gain trade from the passenger steamboats travelling on the river. Another was built on three pontoons in 1870. This was removed in 1901 to allow the building of Dundee Wharf. Another was built (possibly the one shown in the old image in 1905) for the penny steamer service running on the Thames at the time. The modern image shows the river looking towards the Isle of Dogs.

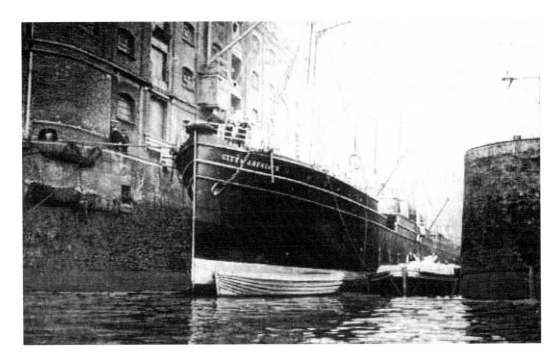

Limehouse

Limehouse was a port from medieval times. Crews for ships were often recruited from the large populations of Chinese and Lascars who lived in the area. Limehouse had a very unsavoury reputation. The area was well known for its opium dens. The modern image shows the entrance to the dock that is now used for pleasure craft. The road passing across the entrance is a swing bridge, which closes while craft pass in and out of the dock.

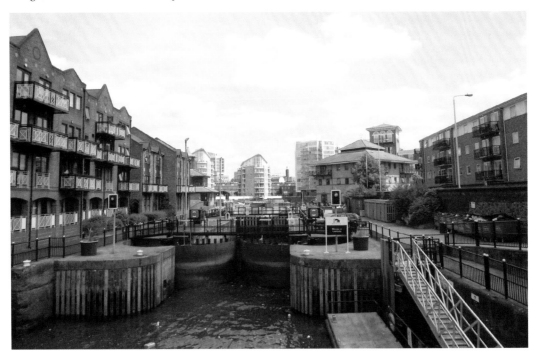

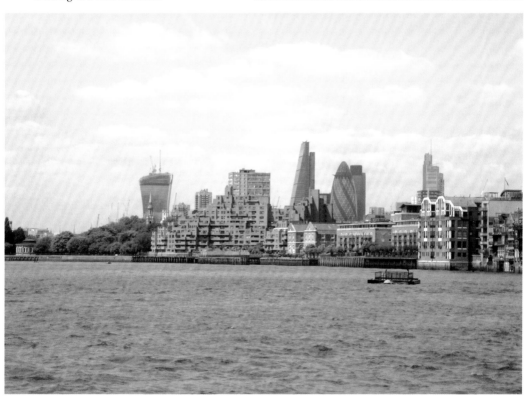

Dock Strike at Limehouse

The docks were notorious for the number of strikes that occurred, especially as the dockers were often seen as among the most militant of workers. This perception dates back some time to the famous Docker's Tanner strike of the early twentieth century. The old image shows Limehouse Docks at a standstill during one of these strikes. The modern image shows the view from Limehouse looking towards London.

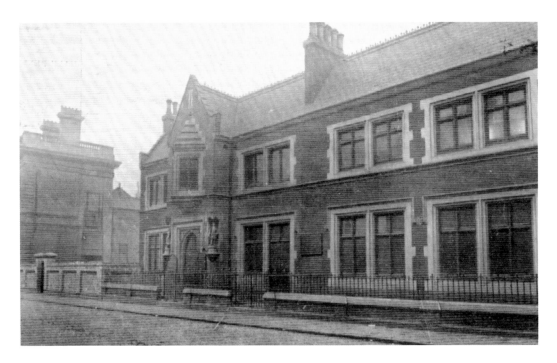

Green Coat School

The Green Coat School in Stepney has a history that dates back to the eighteenth century. Many of the early schools in the area were opened by local dignitaries. These men often had connections with the docks and shipping. The old image shows the school building as it was in the nineteenth and much of the twentieth century, when the pupils would have been the children of dockers who lived in the area. The modern image shows the present school building.

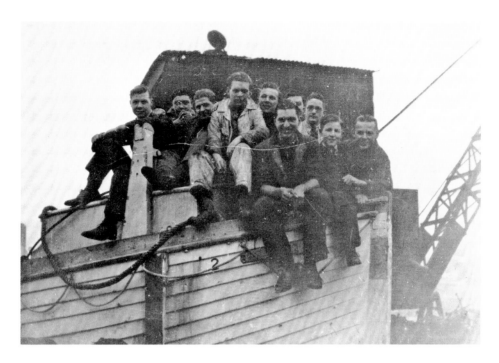

Apprentices at the Docks

The old image shows a group of apprentices at the docks before the Second World War. Apprentices were in an unusual position in having secure employment in comparison with many other dock workers, whose employment was on a casual basis. The men often did not know if they had any work until they arrived at the dock gate, sometimes after a very long walk to get there. The modern image shows a view of the river from Rotherhithe looking towards the Isle of Dogs.

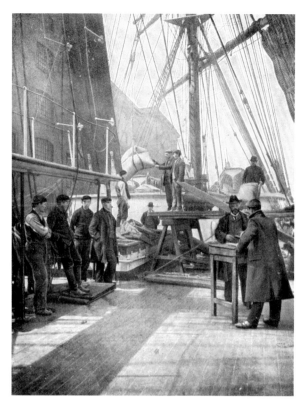

Unloading

The old image shows a ship being unloaded while a number of men stand around watching. The photograph is from the early years of the twentieth century and shows an old sailing ship. The modern image shows some of the old dock warehouses that have survived and are now up-market residences at St Saviours Dock Bermondsey. This would have been where the goods were stored once they were unloaded from the ships.

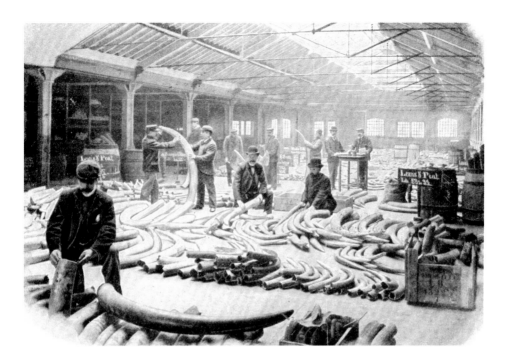

Ivory Warehouse

In the past goods were brought from all parts of the world, some of which we would expect to see being imported today. The old image shows an ivory warehouse, an item that is of course illegal to buy today, but would have been a common item arriving from overseas in the past. The modern image shows more of the surviving warehouses in Bermondsey, which are now converted into homes. The connecting overhead footbridges have been left in place.

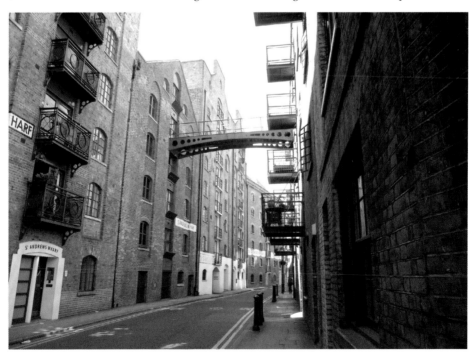

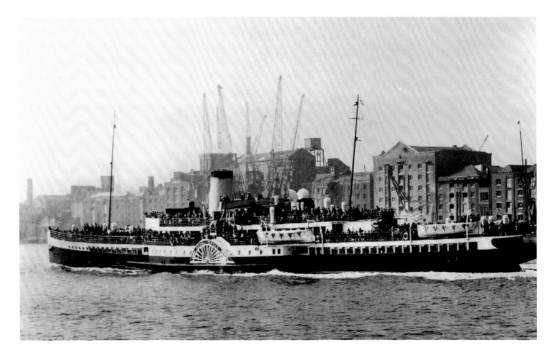

The Royal Eagle Steamer

The Royal Eagle was one of the best known of the old steamships that carried passengers along the river and down to the coast or popular recreations parks such as those at Gravesend or closer to London at Woolwich. The steamers often carried different classes of passenger with a special deck and salon for the better-off travellers. The modern image shows one of London's present passenger-carrying craft passing the Isle of Dogs.

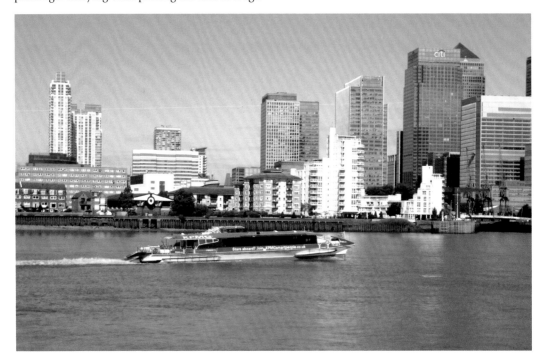

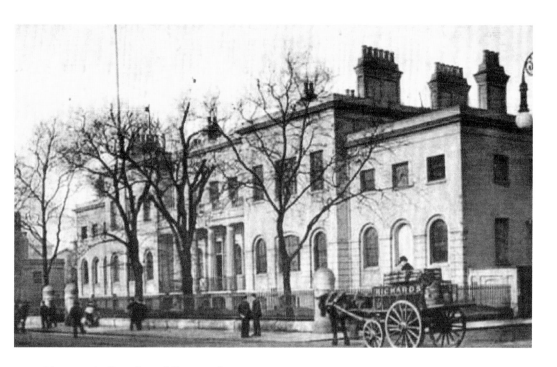

The Board of Trade Building, Poplar

The old Board of Trade building in East India Dock Road has a long history and was built as a seaman's home in 1834 by a local ship owner called George Green. In 1856 it became a school of navigation before it was taken over by the Board of Trade. In keeping with the areas close connection with the docks, this was where the administration duties of the Merchant Navy was dealt with. It closed in 1978, and has now been converted into flats.

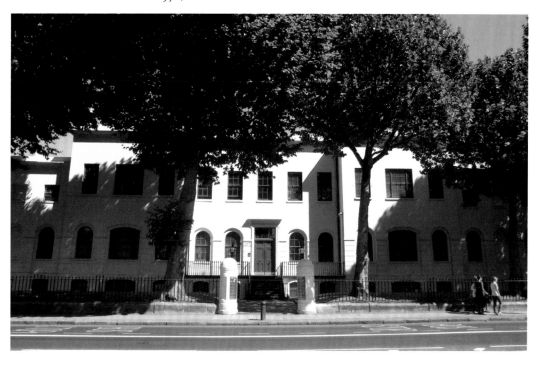

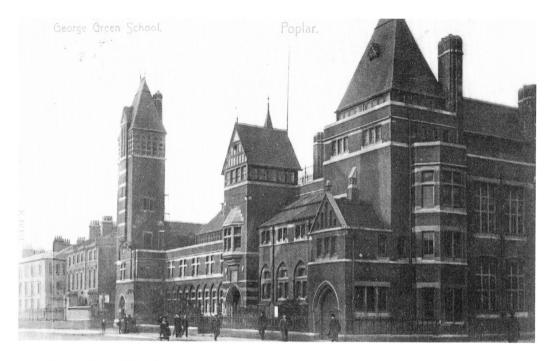

George Green School, Poplar.

George Green School

George Green was responsible for a number of charitable institutions such as the seaman's home based in the Board of Trade building and also the school that bears his name in East India Dock Road, as well as other schools in the area. Green was a shipbuilder that had premises at Blackwall. The original school was opened in 1828 and replaced by the present building in the old image that was built in 1884. In 1976, the school moved to Manchester Road in the Isle of Dogs. The old building became part of Tower Hamlets College.

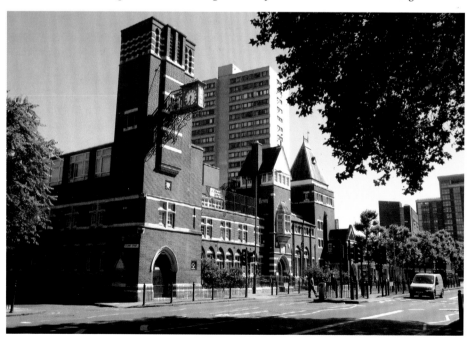

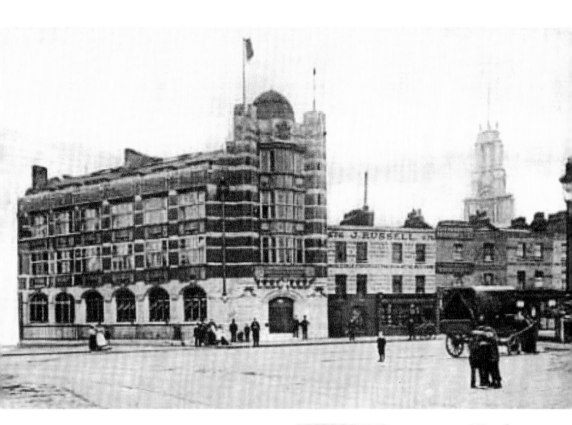

The Sailor's Palace

The Sailor's Palace stands on the corner of East India Dock Road and Commercial Road. It was opened in 1901 due to the generosity of Passmore Edwards, who was responsible for a number of public buildings, such as libraries, in the East End of London. It was known as The Palace due to the quality of the accommodation. It was built to be the headquarters of the British and Foriegn Sailor's Society as well as having accommodation. It also housed the King Edward VII Nautical School. As with many other old buildings, it has now been converted into flats.

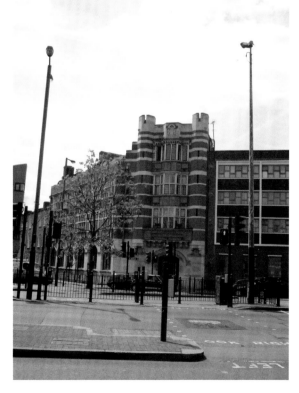

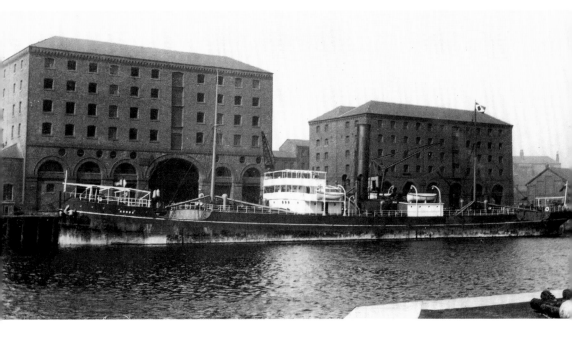

Dockside Buildings

The old image shows the type of buildings that were common alongside the old docks. As well as the docks, places such as Millwall were also the home of shipbuilders such as the Samuda brothers, who by the 1860s were producing twice the number of ships of any other ship builder on the Thames at their works on the Isle of Dogs. Despite their success, the company went out of business in 1890, leaving Yarrow and the Thames Ironworks as the only surviving shipbuilders in London. The modern image shows the buildings that now surround Millwall Dock. They are very different in type and use.

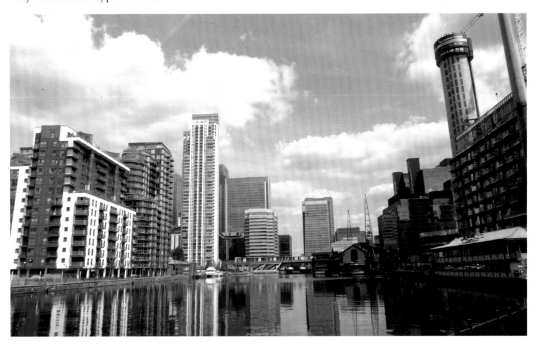

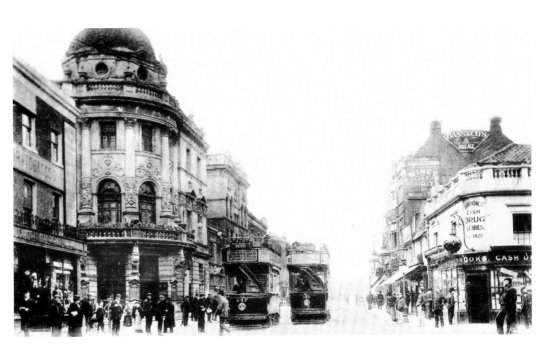

Deptford High Street

Deptford once had an important role in the defence of the country. The first Royal Dockyard was based in the town from the sixteenth to the nineteenth century. It was where Queen Elizabeth I knighted Sir Francis Drake aboard his ship the *Golden Hind*. By the early nineteenth century, large ships found it more difficult to sail up the Thames. The shipyard became more concerned with goods than with shipbuilding, which moved to places such as Chatham. Since the docks have closed, the area along the river has been redeveloped. As the two images show, the High Street has retained many of its older buildings and is still a busy shopping centre for the local population.

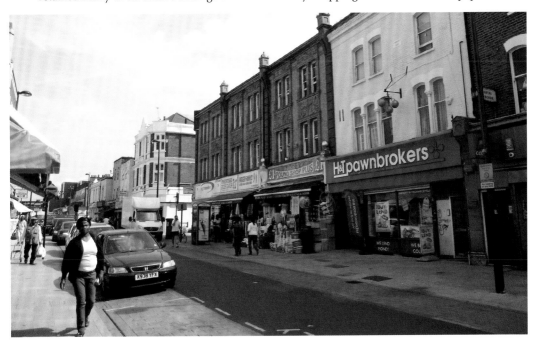

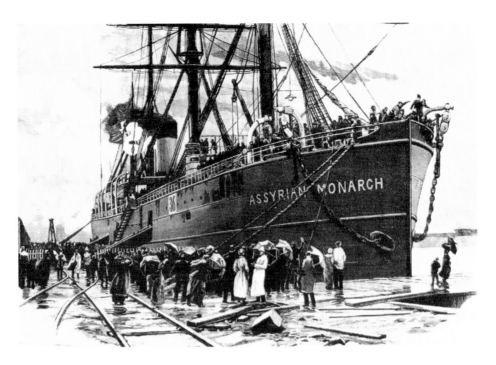

West India Dock

As with many other docks on the Thames, the West India Dock was also used to take passengers on board ships. The old print shows passengers about to board the *Assyrian Monarch*, which was no doubt taking some of the military passengers on the dockside to a war within the British Empire. The modern image shows how the area has changed, although some of the old cranes have been left in place alongside the modern buildings.

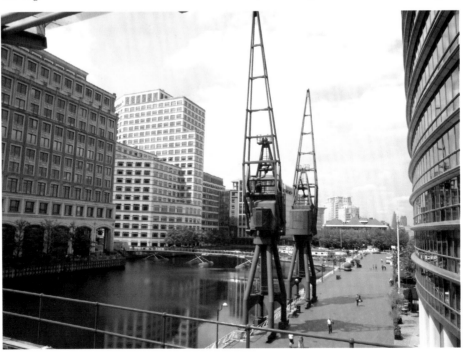

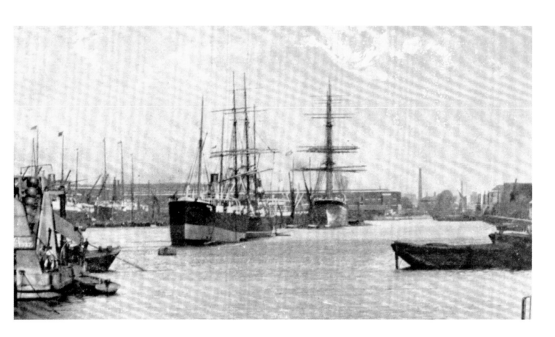

West India Dock

The buliding of the West India Docks were influenced by Robert Milligan, a West Indies merchant and ship owner. He was appalled at the level of theft that occurred at the docks and campaigned for a new dock to be surrounded by a wall. The dock opened in the early nineteenth century. As can be seen from the new image, the West India Dock is at the centre of the major development on the Isle of Dogs. At other parts of the Island, such as at Millwall Dock, little remains of the original buildings. Some of the old warehouses are still in existence alongside the new skyscrapers at West India Dock. These house the Museum of London Docklands and a number of restaurants.

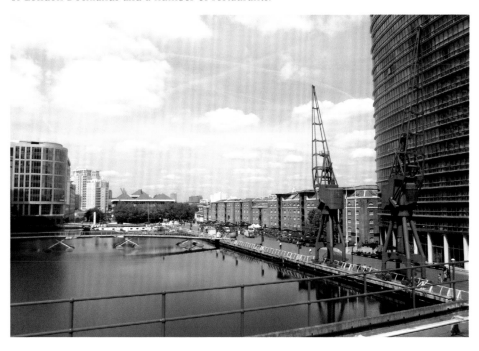

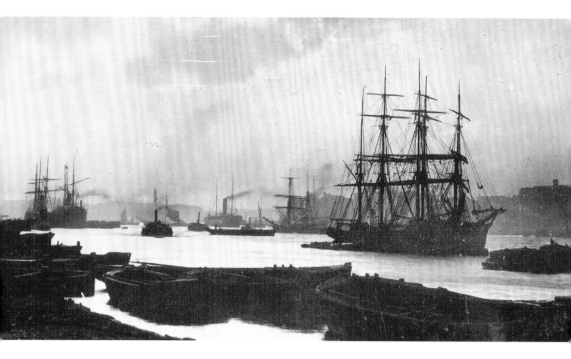

Ships on the Thames

The old image shows how full of activity the river once was, with old sailing ships, barges and other craft almost filling the whole surface of the Thames. This was the norm at the height of the busy docks. The scene on the river is very different today, although in central London the number of pleasure craft on the river is still very high. As you travel further downriver it is much quieter. The modern image, looking towards London from Woolwich, shows the river is almost empty.

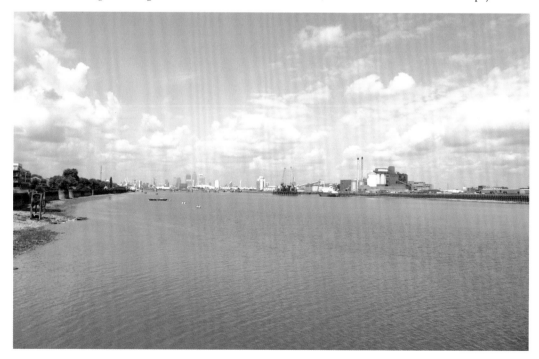

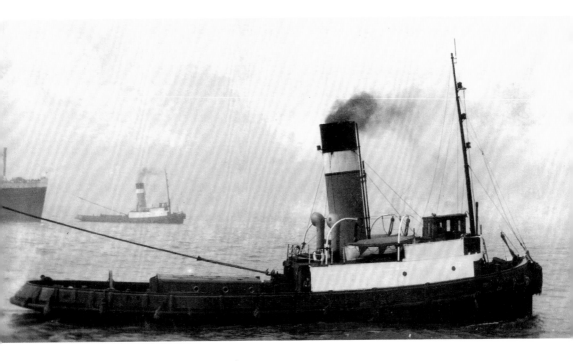

The Steam Tug Poplar

Steam tugs have a long history on the Thames. They have been used to pull larger craft and barges along the river since the early nineteenth century. The first steam tug on the Thames was the *Majestic* in 1816. The early tugs were paddle steamers with an engine controlling each paddle. Screw tugs began to appear from around 1860. Steam tugs continued to operate up until the 1920s, but were eventually replaced by diesel powered craft. The modern image shows the great variation of the craft now operating on the Thames. It also shows what seems to be an old landing craft.

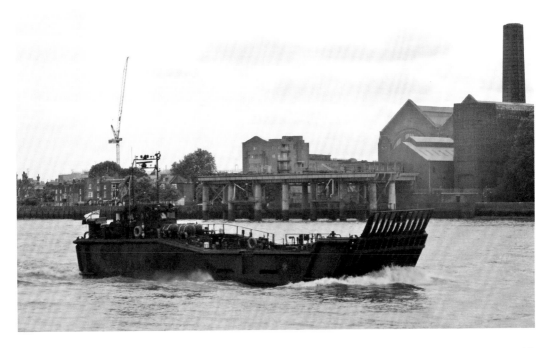

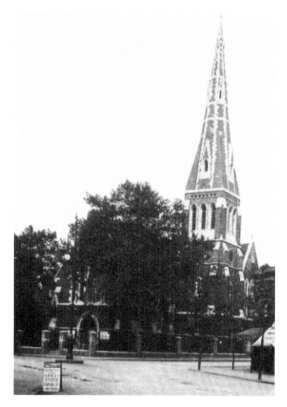

Christ Church, Cubbitt Town

The site for the Christ Church building was given to the Bishop of London in 1847 by William Cubbitt. It was Cubbitt who was responsible for the development of the area in the 1840s. Cubitt was a local businessman who owned a number of businesses and built homes for the workers to live in. He was also Lord Mayor of London from 1860 to 1862. Cubbitt Town was named after him. The church was built between 1852–54. St John's church in Roserton Road was bombed in 1941 and demolished in the 1950s. In 1965 the church was renamed Christ and St John's.

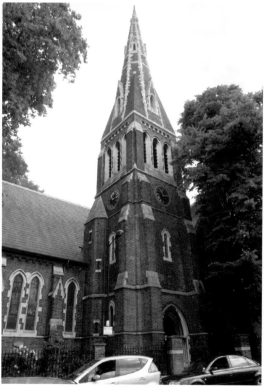

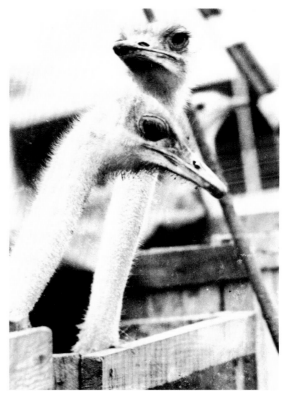

Animals at the Docks

Some of the things arriving at the docks would have been frowned upon today. The old image shows some ostriches arriving at the docks around the time of the Second World War. They were bound for Bristol Zoo, and the shipment also included a gazelle. There were three more ostriches in the consignment, two had died on route, and a third had jumped overboard. The modern image is a view across the river to the entrance to West India Dock.

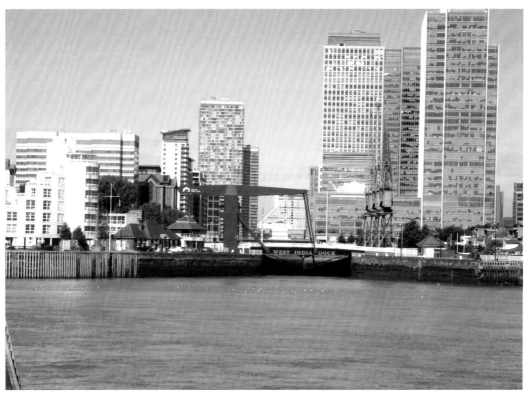

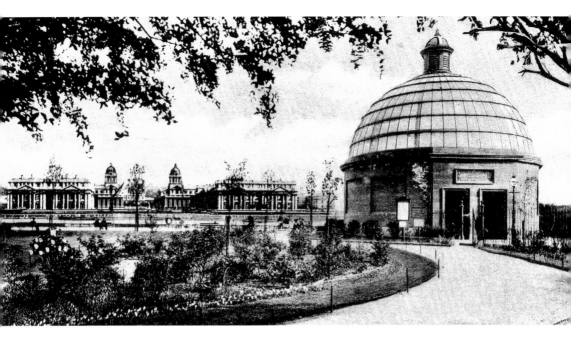

Greenwich Foot Tunnel

The Greenwich Foot Tunnel was designed by Alexander Binnie for the London County Council and opened in 1902. It was built to replace a ferry that previously operated in the area so that workers from south of the river could reach the docks on the north. It is open twenty-four hours a day, and the entrance on the north bank is situated in Island Gardens. On the south bank the entrance is close to the *Cutty Sark.*

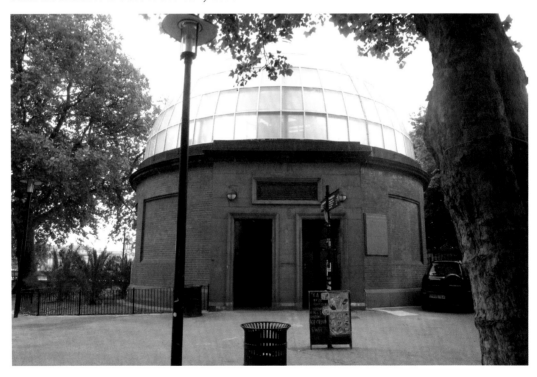

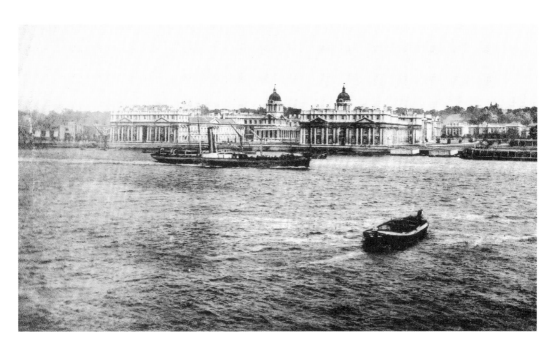

Greenwich

Greenwich has a long maritime and royal history. There was a royal palace there from the fifteenth century and many of the Tudor royal family were born there. The palace fell into disrepair during the Civil War and later became the Royal Naval Hospital. Due to the town's naval history, it was chosen as the site of the National Maritime Museum in the 1930s. The modern image is a view from Island Gardens on the tip of the Isle of Dogs. It is a popular spot for artists due to the wonderful views across the river.

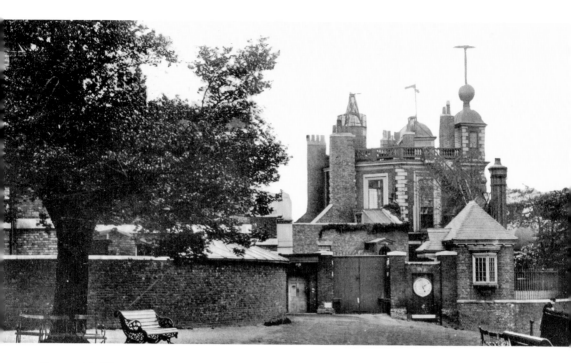

Greenwich Observatory

The Greenwich Observatory opened in the reign of Charles II in 1675. The original building was designed by Christopher Wren and included the house of the astronomer. The first Astronomer Royal was John Flamstead. In keeping with Greenwich's naval traditions, one of the results of the work at the Observatory was the accurate recording of longitude to aid navigation for the ships travelling the world.

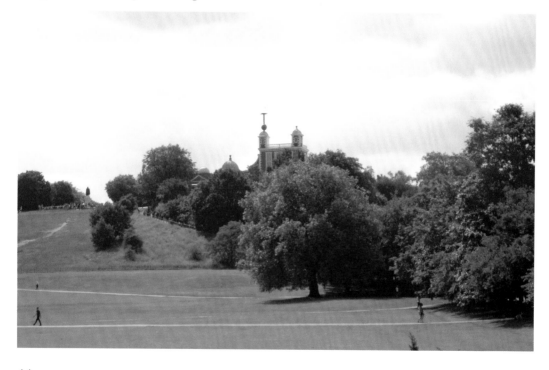

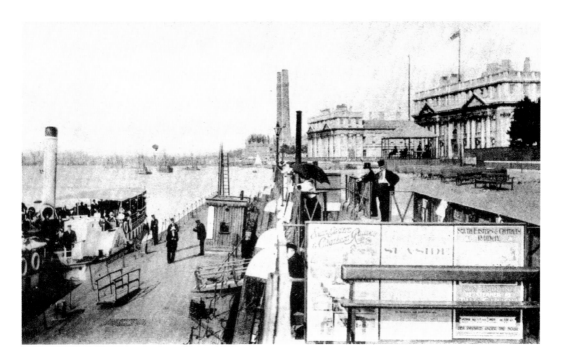

Greenwich Pier

Greenwich Pier is used by a number of companies running river services in London. There are a number of options when travelling to Greenwich by river, rather than using the normal tourist routes such as the underground. The pier has been used as a landing place for those travelling on the River Thames for a long period throughout history. It was often the destination for ships arriving in the country from abroad.

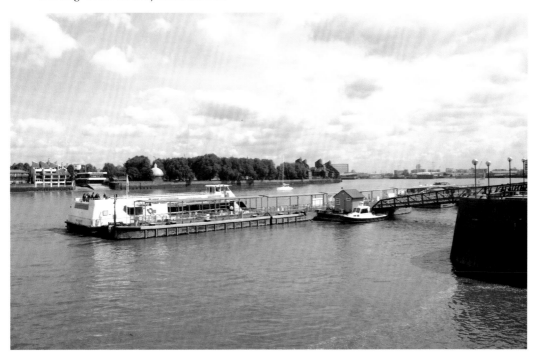

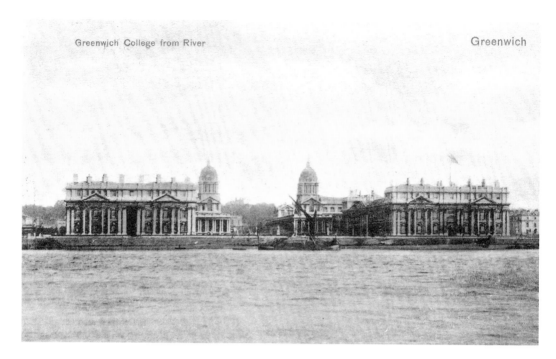

Greenwich Hospital

The Greenwich hospital was for Royal Naval personnel, and was similar to the Chelsea hospital for soldiers. It was built in the reign of Charles II and designed by Christopher Wren. It operated from 1692–1869. It is said that when Queen Caroline arrived at Greenwich in 1795, she thought all Englishmen had one arm or one leg because of the number of hospital inhabitants she saw. The gap in the middle of the building was to stop the view of the river from the Queen's house being blocked. The building later became the Royal Naval College.

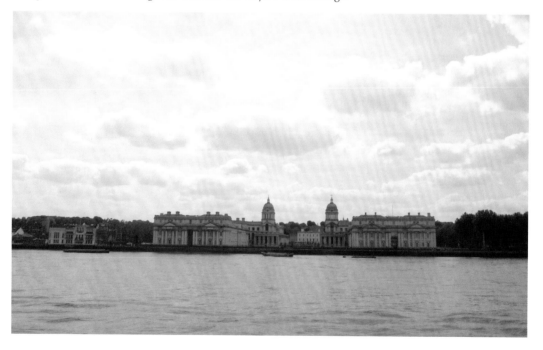

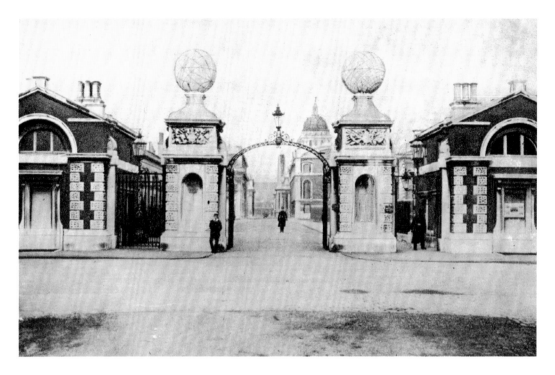

Greenwich Hospital Gates

The old image shows the grand main west gates closest to Greenwich itself. The globes on the top of the gateposts commemorate Admiral George Anson's circumnavigation of the world from 1740–44. The modern image shows the water gate that is seen if you approach the building from the river. It replaced a rather plainer eighteenth-century gate in 1850.

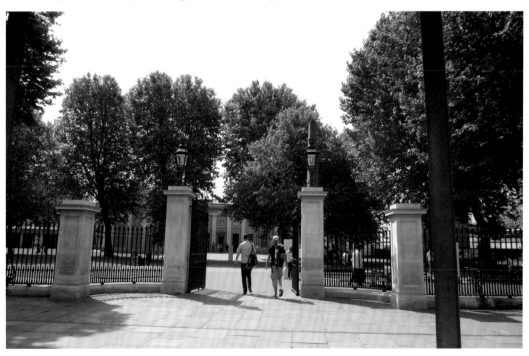

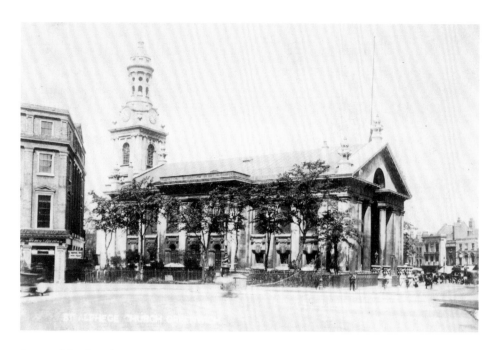

Greenwich Church

St Alfege Church in Greenwich was built between 1712–14 and designed by Nicholas Hawksmoor. It stands on the site of much earlier churches, including one where Henry VIII was baptised. It has connections with seafaring that go back far into history as it supposedly stands on the spot where St Alfege, the Archbishop of Canterbury, was murdered by Vikings who had taken him prisoner at the sacking of Canterbury in 1011.

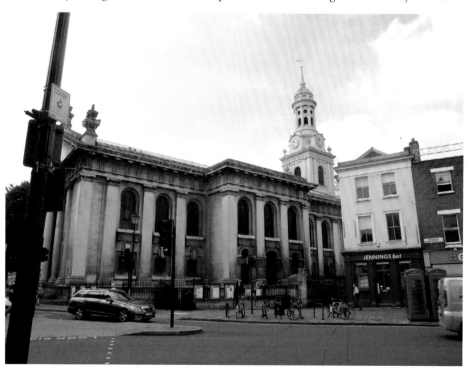

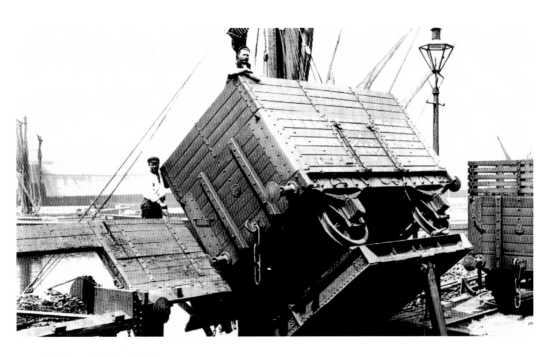

Railways in the Docks

Many of the docks had their own rail lines to carry goods in and out from the ships. These were often small local lines, but some docks were connected to the main rail lines. The old image shows how some rail trucks could tip to make loading and unloading easier. The modern image shows the view across the river from North Greenwich close to the O2 stadium.

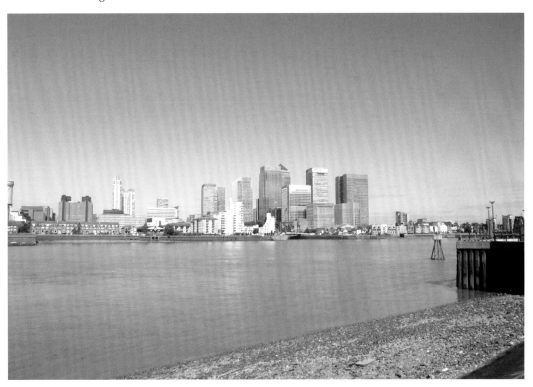

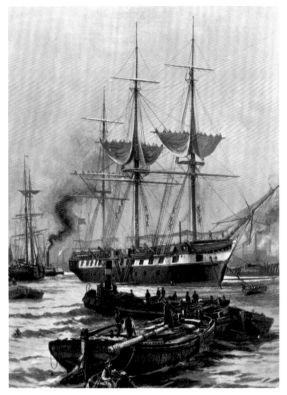

Warsprite Training Ship

Apart from ships that were bound to the docks, the Thames was the site of a number of training ships where young boys, often from orphanages, were sent to train for the Navy. This was often used as a way of getting rid of poor boys that were a burden on local ratepayers. These ships were often moored further downriver. The *Warsprite*, however, was moored off Woolwich until the turn of the century when it moved downriver to Greenhithe. The modern image shows the river at Woolwich looking towards London today.

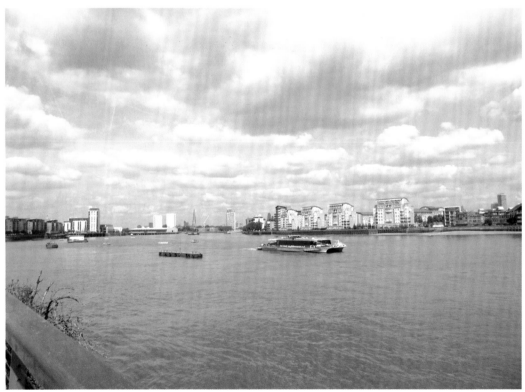

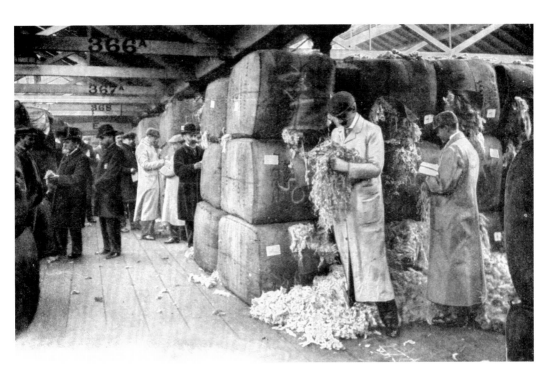

Buyers at the Docks

The old image shows buyers at the docks who would come to see what was for sale after the goods arrived and were moved into the nearby warehouses. The men in the old image seem to be testing the quality of what looks like bales of wool. Visitors of the docks today tend to be tourists or pleasure boat owners, as the modern image shows.

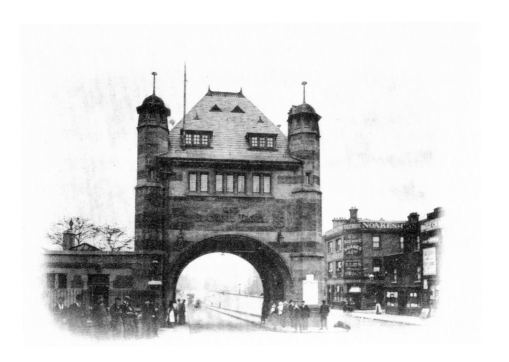

Blackwall Tunnel

The old image shows the entrance to the tunnel on the northern side of the Thames. It was opened in 1897 by the Prince of Wales, designed by Alexander Binnie and built by S. Pearson & Son. Around 600 people lost their homes due to the construction of the single tunnel that supposedly included a house once owned by Sir Walter Raleigh. The modern image shows the northern exit of the northbound tunnel.

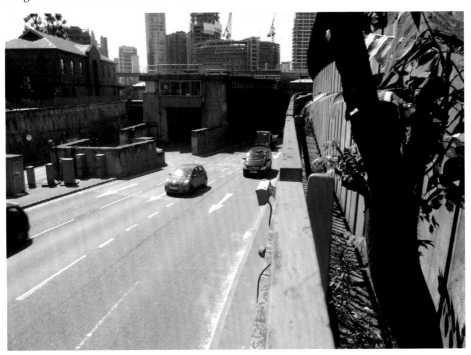

Blackwall Tunnel

The old image shows the entrance to the northbound tunnel on the South Bank of the Thames. The form of transport using the tunnel has changed from horse-drawn to motorised traffic. When the tunnel was built, it included a number of bends that were supposedly incorporated to stop horses being scared. There is also a rumour that the bends were a result of the tunnelers finding old plague cemeteries that they diverted to avoid. Seven men died during the tunnels construction.

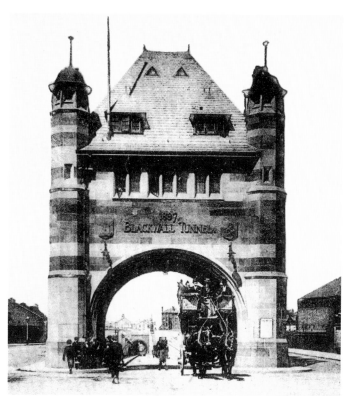

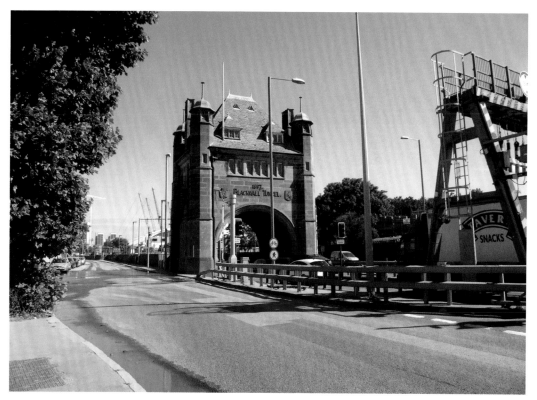

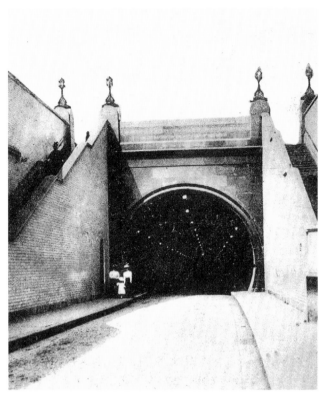

Blackwall Tunnel

The old image shows the entrance to the tunnel being used by people on foot. This was allowed when the tunnel opened, as seen by the steps leading down to the entrance. The sign in the modern image shows that foot traffic is no longer allowed. This is the exit of the southbound tunnel with the O2 in the background. This is the second tunnel, which was opened in 1967. Before this, there had only been a single tunnel. The south sides of the tunnel stand in a strange position as to the east of the tunnels there is the O2 and other modern buildings around it. West of the tunnels; the area is much more industrial and, in parts, is almost derelict.

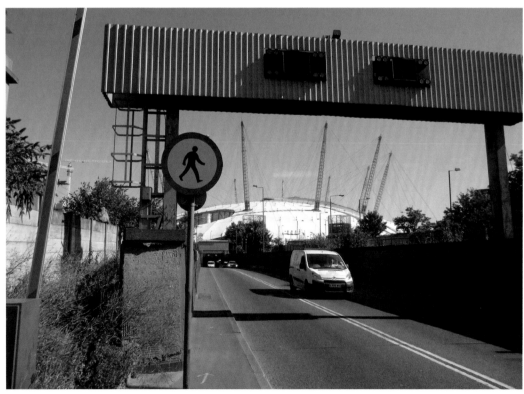

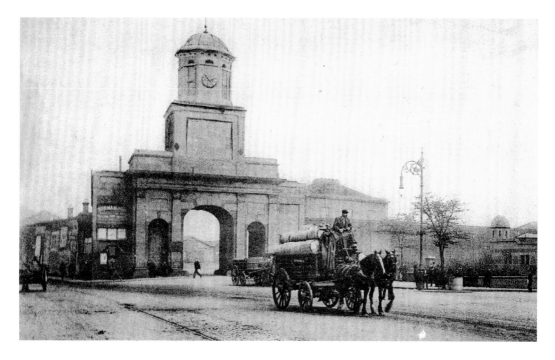

East India Dock

The East India Docks were built in the early nineteenth century to deal with imports from the East India Company. They could deal with more than 200 ships at a time, and the revenue exceeded £30 million a year for tea alone. The dock could not deal with larger ships that later began to replace the company clippers they were built for. The old image shows the entrance to the dock, while the modern one shows the remains of some industry in the area and the use for the docking of modern craft.

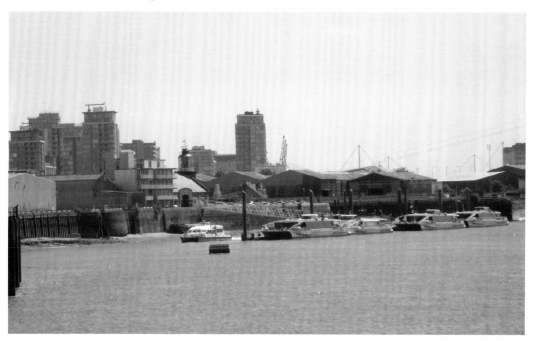

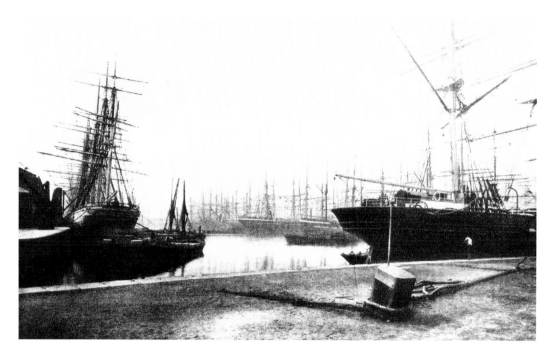

East India Dock

The old image shows the dock full of the East India Company clippers. During the Second World War the dock was used as a site to build Mulberry Harbours for use on D-Day. The area was heavily bombed. After the war, the dock was usually used for maintenance work. A power station was built on the site, which was later demolished. The docks closed in 1967, but many of the nearby streets bear the names of the goods that were handled by the dock at the height of its use by the East India Company. The modern image shows the view of the O2 arena across the river.

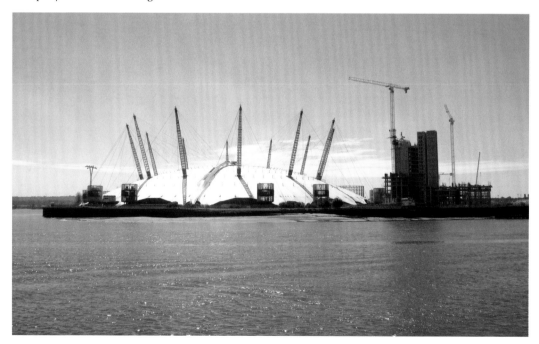

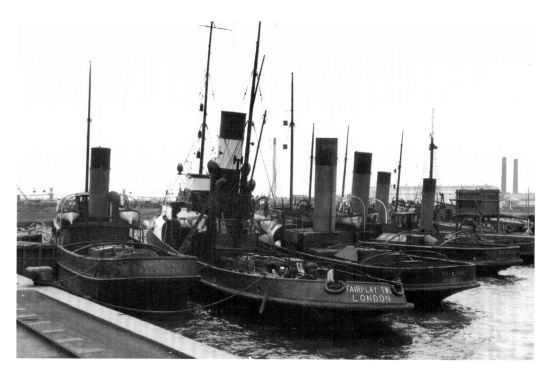

Thames Tugs

The old image shows a number of tied-up tugs that were undoubtedly waiting for work on the Thames. The tugs are much rarer on the river today, although some are still in use. The docks that remain, such as the one in the modern image at Limehouse, are now full of pleasure craft instead of working boats.

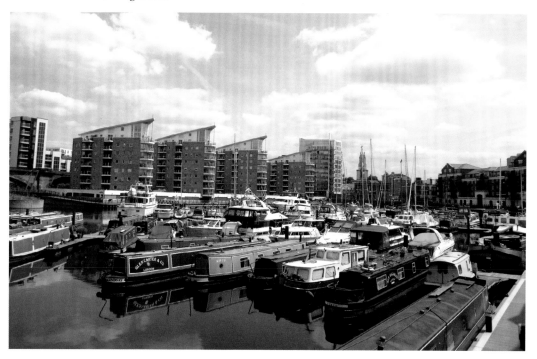

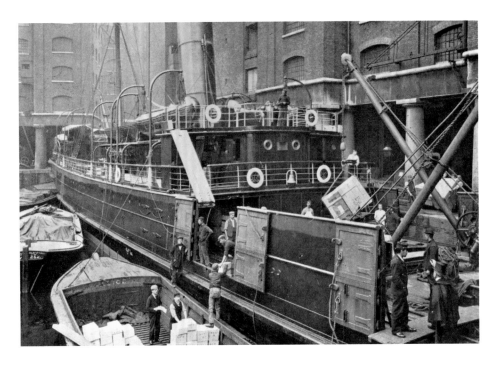

Unloading

The old image shows a ship being unloaded by hand. This undoubtedly depended on the type of goods that the ship was carrying. Cranes became more commonplace in the docks that dealt with larger ships, and many of the old cranes have been left in place, even where the areas have been completely redeveloped. The cranes in the new image are in Millwall Dock alongside the modern buildings, giving an insight into that which has now gone.

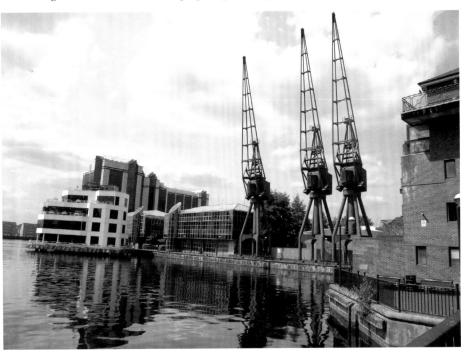

Bomb Damage

The London docks were one of the most heavily bombed areas in the country during the Second World War. The homes of those living nearby also suffered, and many of the locals moved away. Some residents even set up camps in Epping Forest to escape the bombs. Some dockland areas were so empty of inhabitants that they were used to train troops in street fighting. There is no longer any sign of bomb damage in the areas that have been redeveloped, such as the modern view of West India Dock.

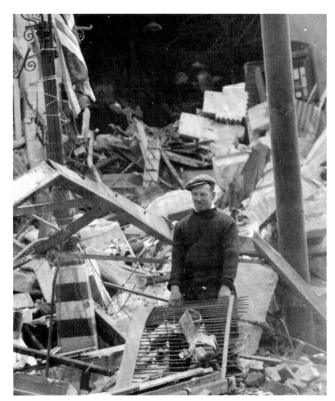

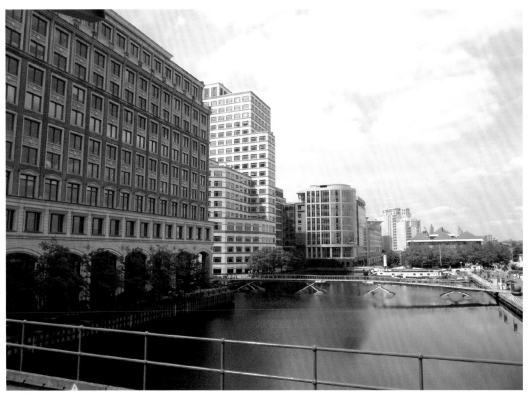

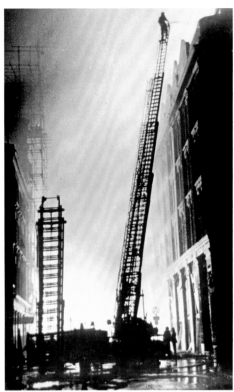

The Docks Burning

When the first air raids of the Second World War began in 1940, they were concentrated on the docks and the surrounding areas. The fires in the docks were so bad that they could be seen 10 miles away when darkness fell. This then guided the German night bombers who continued the attacks. The old image shows how difficult it must have been for the fire services in narrow streets lined with high warehouse buildings on both sides. The modern image shows some of the similar streets that have survived.

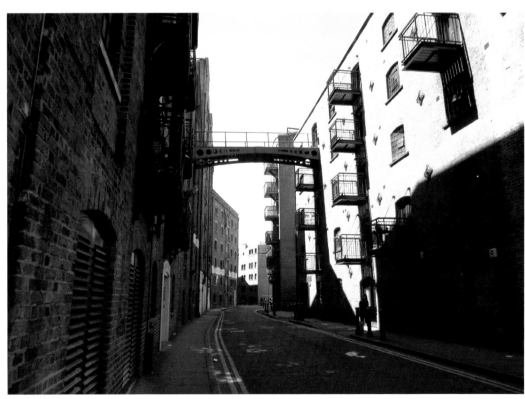

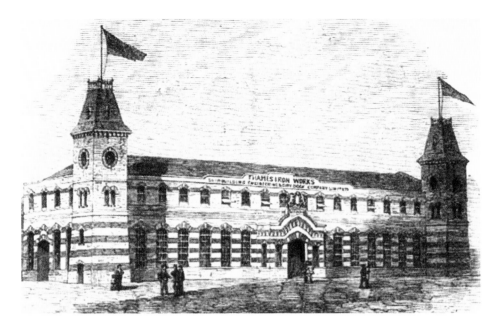

Thames Ironworks

As well as being known for the docks, the banks of the Thames were also the site of a number of shipbuilders. They built many of the largest and most powerful ships in the world up to the early twentieth century. One of the best known, and the last to survive was, the Thames Ironworks, which was based on Bow Creek. It is best remembered today for its company football team, known as West Ham United. The team badge shows the crossed hammers that were the tools of the old shipbuilders; it is the origin of the team's nickname 'the Hammers'. The team has played at the Boleyn Ground at Upton Park for many years, but will soon move to the Olympic Stadium at Stratford. Although many fans see this as a betrayal of the teams roots, the stadium stands on the banks of the River Lea, which is the same river on which the Ironworks once stood.

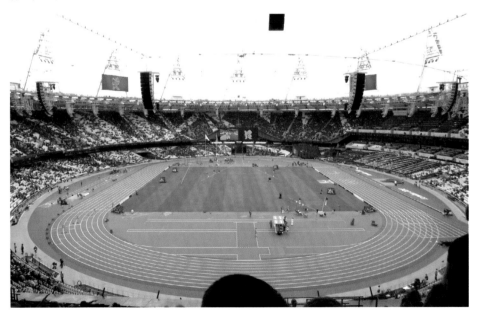

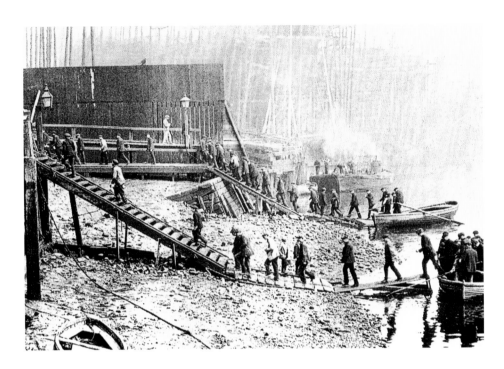

Thames Ironworks

The old image shows men arriving for duty at Thames Ironworks. The scaffolding around a large ship in the background shows the huge size of the ships that were built. The site is close to Canning Town and the railway station includes a memorial that has an armoured plate of the type they used to protect the battleships they built. Many of these ships took part in the naval battles of the First World War. The modern image shows a view of Bow Creek from the Docklands Light Railway platform of Canning Town station.

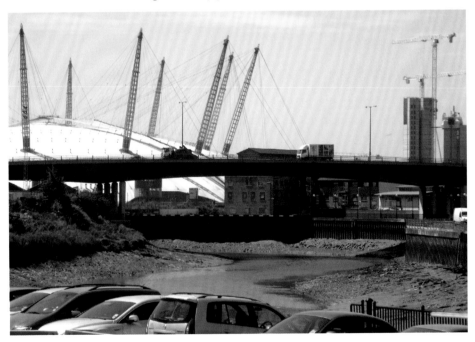

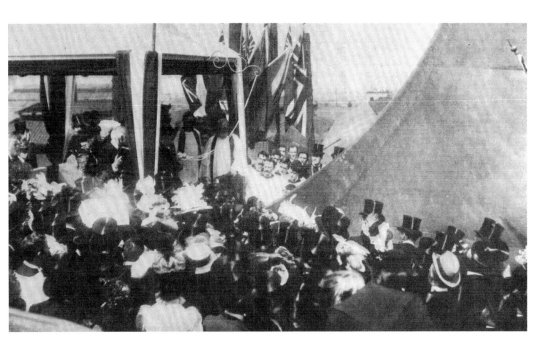

Royalty at the Ironworks

The launch of a ship at the Thames Ironworks was a big local event. When the *Albion* was launched in June 1898, there was an estimated crowd of 30,000 watching. The ship was a cruiser; 390 feet long by 74 feet wide and weighing 6,000 tons. Local school children were given the day off to attend the launch, which was initiated by the Duchess of York. The ship was launched and the royal party left unaware of any problem. The old image shows the royal party and the dignitaries present at the launch. The modern image shows the mouth of Bow Creek, where the Ironworks were situated, from across the river at Greenwich.

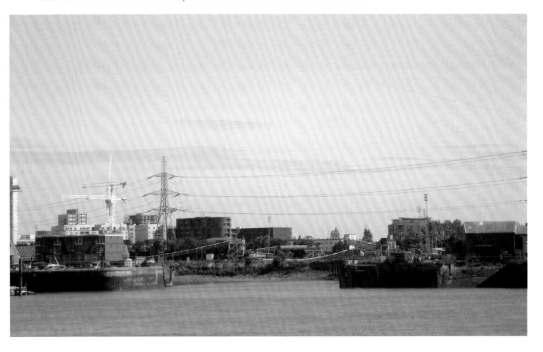

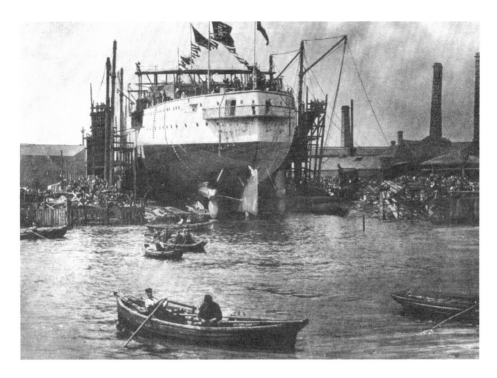

The Albion Launch

The launch of the *Albion* was the site of one of the most serious disasters ever to occur in the Docklands. Amongst the crowd of 30,000 people, there were around 200 spectators who were standing on a temporary causeway despite being told that it was dangerous. Due to the narrow space between the banks of the Creek, ships were launched sideways into the water. As the ship slid into the creek, it caused an enormous wave that washed over the causeway destroying it and plunging the spectators into the water. Thirty-eight of them drowned, including women and children. There was a widespread appeal, and a fund was set up for the families of the victims. They were buried in the East London Cemetery in a mass grave shown in the modern image.

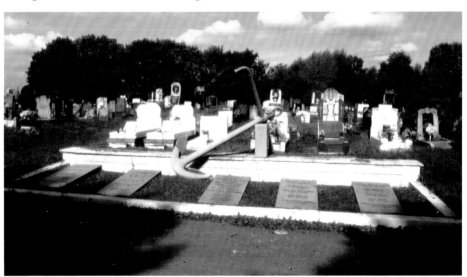

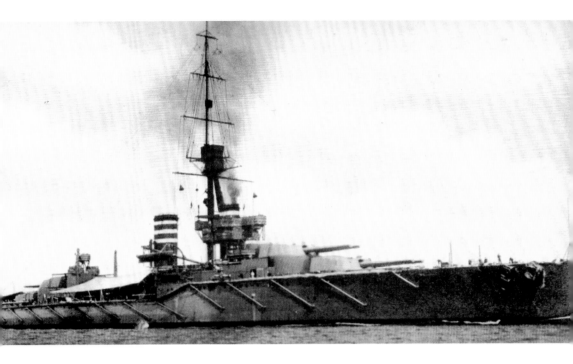

The *Thunderer*

The *Thunderer* was the largest battleship built on the Thames. It weighed 22,000 tons and had ten, 13½ inch guns in turrets. It was launched in February 1911 and was the last ship built by Thames Ironworks. The yard had been losing orders to shipyards in the north of the country, and after the *Thunderer,* the yard was declared bankrupt. The modern image shows the memorial to the Ironworks in Canning Town railway station. It includes a sheet of armour plating and details of the ships built there throughout the yard's history.

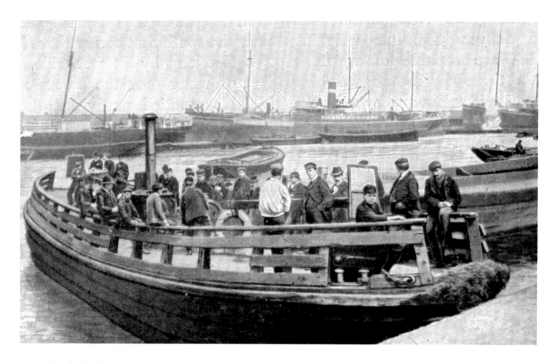

Dock Ferries

There were a number of dock ferries operating on the Thames to carry workers to their jobs from across the river. Some of these were replaced by building foot tunnels such as those at Greenwich and Woolwich, although at Woolwich the ferry continued to operate as well. The modern image shows an old form of craft that has operated on the river for many years and still survives today, called an *Essex Barge*.

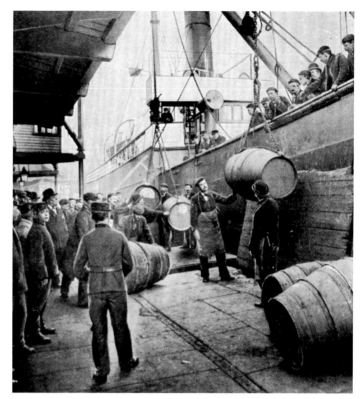

Unloading Wine

The old image shows barrels of wine being unloaded, which seems to have attracted quite a large crowd of spectators. The docks were renowned as the site of widespread pilfering, and no doubt wine would have been a popular objective of the less scrupulous workers. It would have been difficult to get away with such large barrels. The modern image shows old warehouses where such valuable goods would have been stored securely.

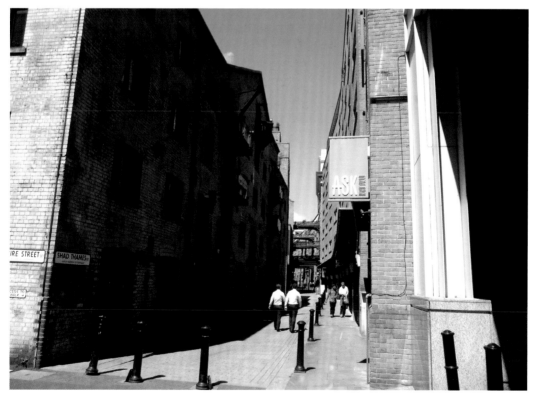

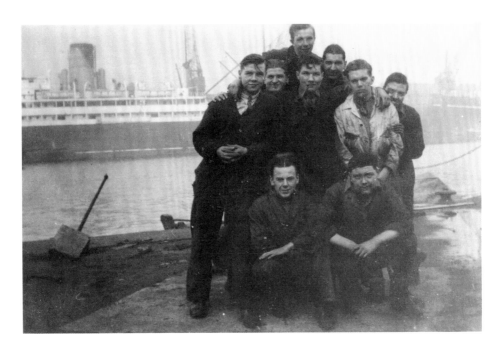

Apprentices at the Docks

The Victoria Dock opened in 1855. Unlike some of the other London Docks, it was built on previously uninhabited land on Plaistow Marshes. It became the Royal Victoria Dock in 1880. It was the built to accommodate large steam ships and was the first dock to be connected with the national rail network. The dock closed in 1980, and although many of the old buildings were demolished, as with other docks, some of the cranes have survived. The group of apprentices from before the Second World War, shown in the old image, would have a problem recognising the docks today.

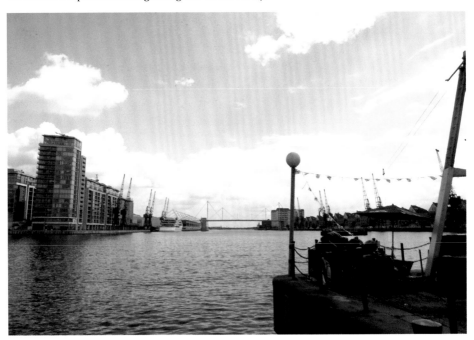

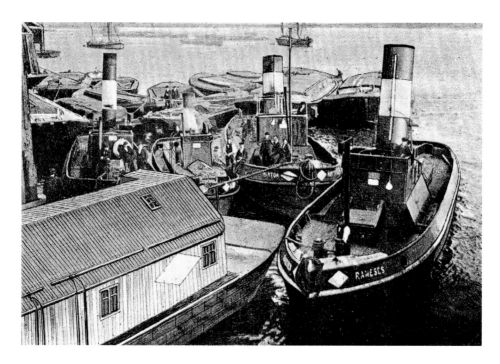

Royal Victoria Dock

The old image of the Royal Victoria dock shows the pier head crowded with tugs and barges. The old dock now has a water sports centre as one of its main uses. The nearby Excel Centre was built in 2000. It covers a 100 acre site, and although essentially an exhibition centre, it was also used as a venue for some of the activities of the 2012 Olympics. The dock has its own Docklands Light railway station and is now a popular tourist centre.

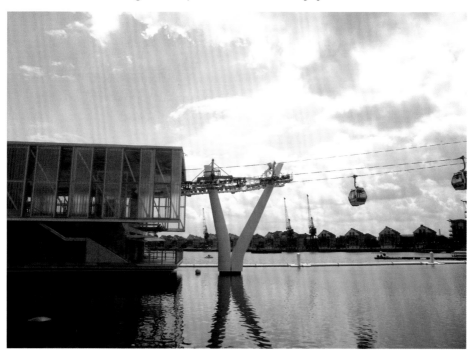

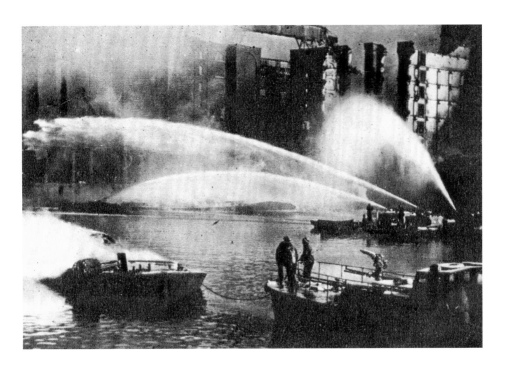

War Damage

One of the advantages of dealing with fires caused by bombing at the docks, was that there was plenty of water available to fight the resulting fires. This is seen in the old image with the use of fire boats firing water onto the flames. The modern image shows the Emirates Air Line or the Thames Cable Car that opened in June 2012. It is 90 metres high and carries passengers from the Royal Victoria Dock to Greenwich Peninsula. There have been some complaints that the air line is a white elephant that is poorly used.

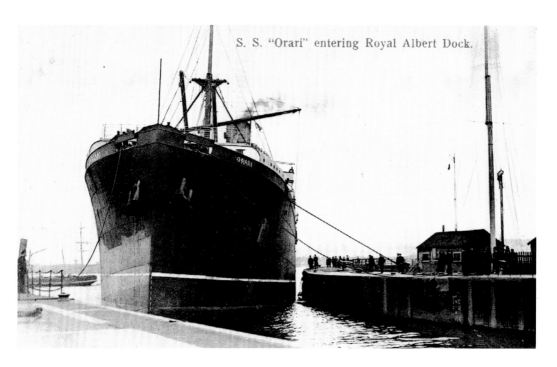

Entering the Royal Albert Docks

The old image shows the steamship SS *Orari* entering the Royal Albert Docks. There are sailing ships in the background on the river showing that the arrival of steamships did not put an end to sail. The dock entrance runs from the Thames towards the Royal Albert and the George V docks. The modern image shows that there have been a number of residential buildings erected in the area since the old image was captured.

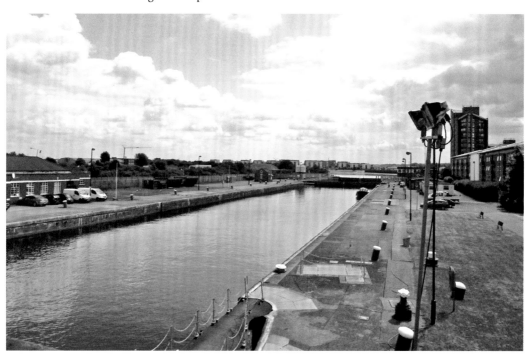

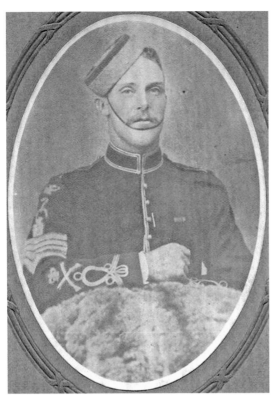

James Carter

The old image shows James Carter; a trooper in the 8th Royal Hussars. This picture dates back to the early years of the twentieth century before the First World War. James later became a stevedore on the docks after leaving the army. Although the men in the docks saw ships from all over the world, the only chance they had of seeing the world themselves was as members of either the Army or the Navy. The modern photograph shows the Docklands Airport where people now travel from all over the world.

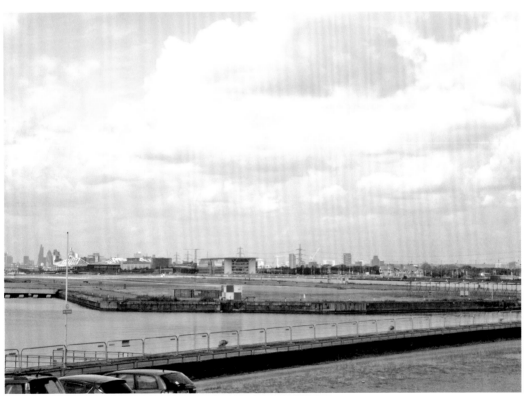

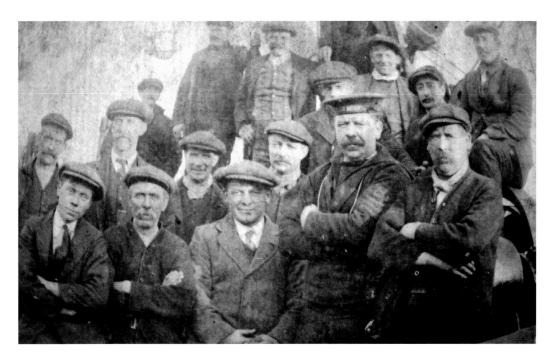

James Carter with Workmates

The old image shows a group of dockers at around the period before the First World War. James Carter is on the far end of the second row. James fell into the hold of the SS *Beltane* while working and later died as a result of his injuries, which helps to depict the dangerous nature of working at the docks. This happened in 1919. James spent his last days in a seaman's hostel. His death left his wife and children almost destitute. The modern image shows a very different view of the Royal Albert Dock from the one that James would have known.

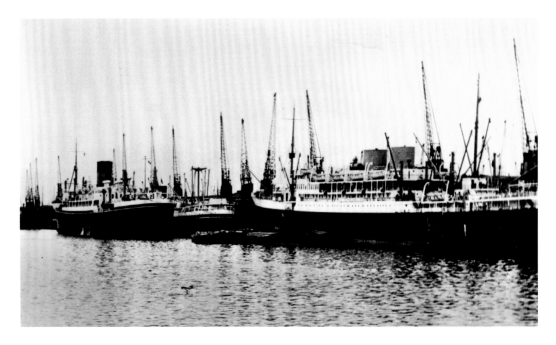

George V Dock

The George V Dock was the last of the royal docks to be completed. It was also the smallest of the three. Construction work began in 1912, but due to the outbreak of the war, it was not completed until 1921. The old photograph shows that although it was the smallest royal dock, it could be used by large ships. The modern image shows the view from the George V towards the Albert Dock with the buildings of the University of East London on the bank. The university moved to docklands from various other sites in east London.

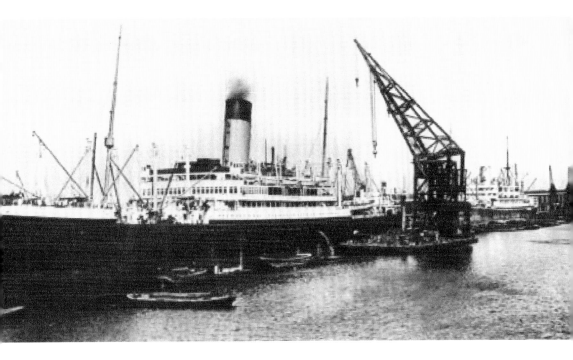

George V Dock

The old image is another view of the large ships that used the George V Dock. The modern image shows an aircraft landing at the Docklands Airport. The runway for the aircraft is on the north side of the dock with the Albert Dock behind it. The airport terminal was built on part of the dock that was filled in after it closed. For some time after the docks closed and before the airport opened the site was used as a large Sunday market.

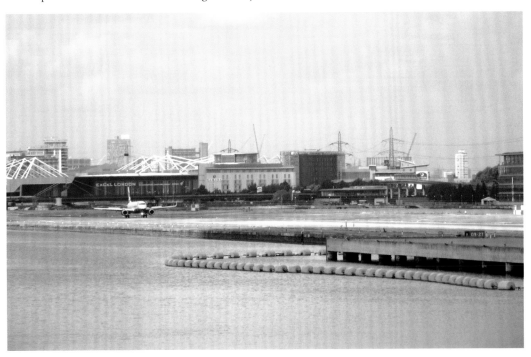

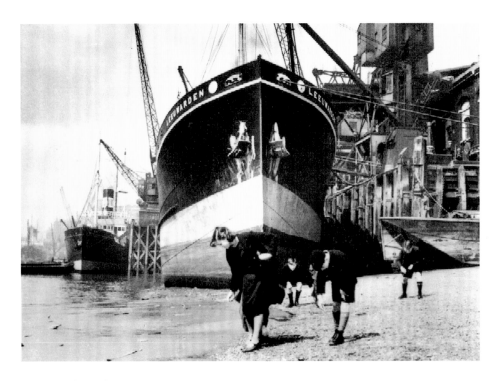

Dock Beachcombers

Despite the knowledge of pilfering that took place in the docks, the old image shows that security was not always very stringent as these children have been allowed to gain access to the bank of the river close to the ships. It is hard to imagine this happening today with the emphasis we have on health, safety and security. The modern image is of the George V Dock looking towards London.

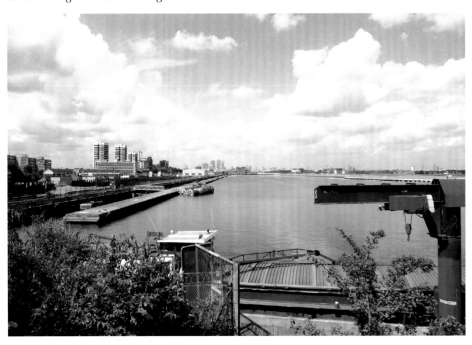

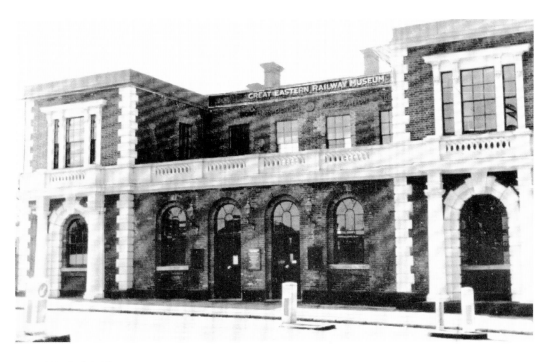

Woolwich Museum

The Woolwich Museum building was originally the terminus of the Great Eastern Railway line built in 1847. It was still used as a ticket office until 1979, when a new building replaced it as the station and it became a railway museum in 1984. The railway line eventually closed in 2006, and the museum also closed a few years later in 2008. It has been empty since then and is beginning to look as though it is deteriorating.

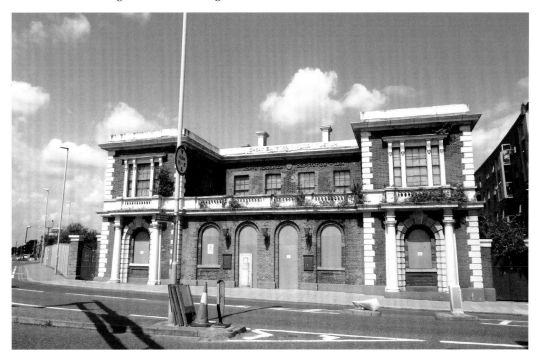

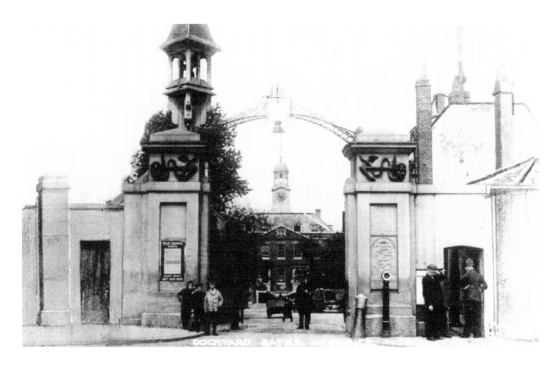

Woolwich Dockyard

The dockyard in Woolwich was opened in 1512 by Henry Vlll to build his flagship the *Henri Grace a Dieu*, the largest ship in the world at that time. As ships became larger, the dockyard became too small to cope with them, closing in 1869. A number of the buildings have survived, including the dock admiral's house, which is now a community centre. The gates to the yard have also survived. They can be seen in the modern image.

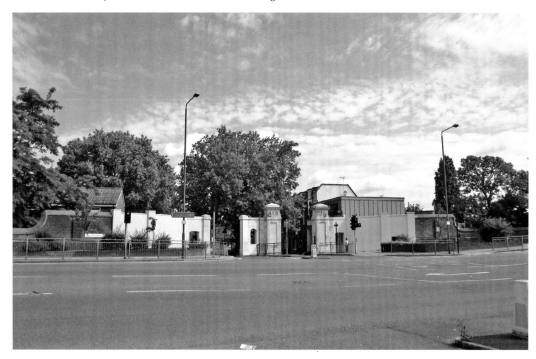

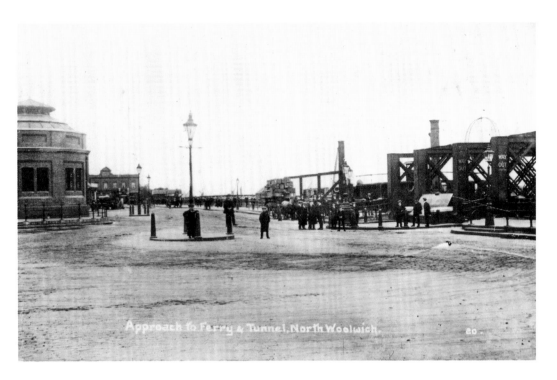

Woolwich Ferry Approach North

The old image of the ferry approaching shows that it was much closer to the foot tunnel than it is now. The ferries in the past were side loaded, but the volume of traffic was much lower than it is today. The ferries approach has changed with the later ferries. The approach was renewed in 1970. The new image shows the northern approach from the river.

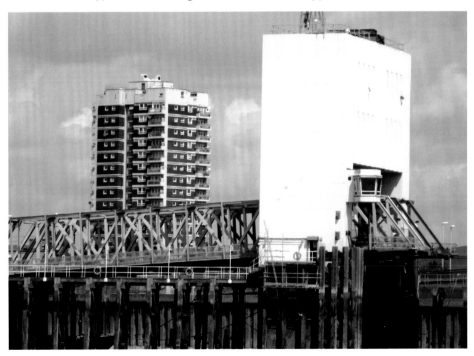

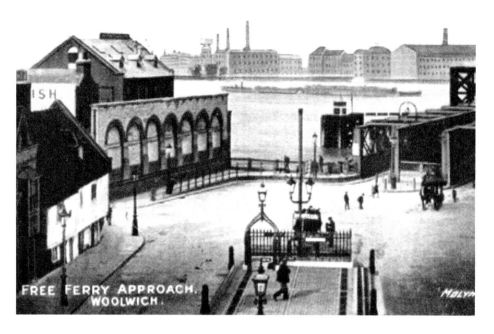

FREE FERRY APPROACH.
WOOLWICH.

Woolwich Ferry Approach South

The ferry approach on the south was once dominated by more interesting buildings than on the north. There was the Woolwich Power Station, which has since been demolished, and part of the old Woolwich dockyard. The approach was altered in the mid-1960s, and as can be seen from the new image, it is much busier with larger vehicles now using the ferry.

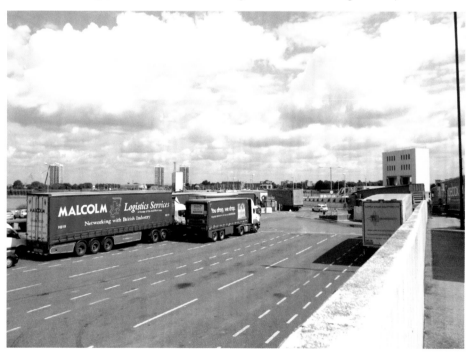

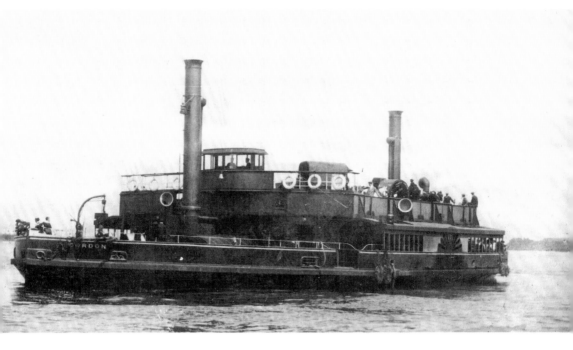

Woolwich Ferry

There has been a ferry of sorts at Woolwich as far back as the fourteenth century. The opening of the *Arsenal* south of the river led to a great increase in traffic, and the army eventually opened their own ferry in 1810. There were a number of other ferries operating at this time until the newly formed London County Council took control of a new ferry in 1889. The ferry has ran until the present day and is the only major ferry to survive on the Thames above Tilbury. The present ferries, as shown in the new image, were built in 1963.

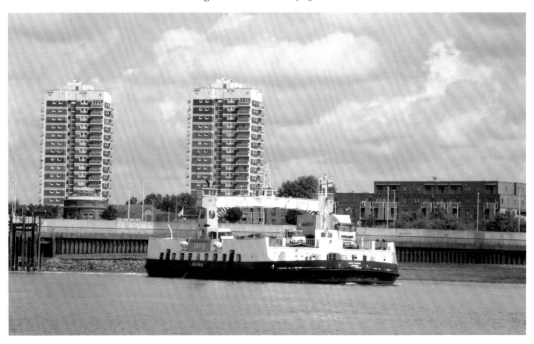

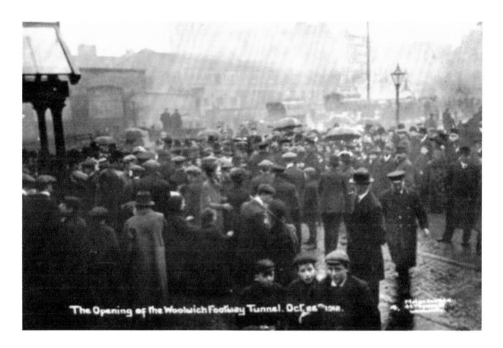

The Opening of the Woolwich Footway Tunnel. Oct 26 1912.

Woolwich Foot Tunnel

The foot tunnel at Woolwich opened in October 1912. It was designed by Sir Maurice Fitzmaurice for the London County Council. The Labour MP, Will Crooks, who had worked on the docks, had an influence on the tunnel's construction as well as the tunnel at Greenwich. The modern image shows that the northern tunnel entrance is now further away from the ferry approach than it was before the approach was changed in the 1970s. The tunnel entrance south of the Thames is now surrounded by new buildings.

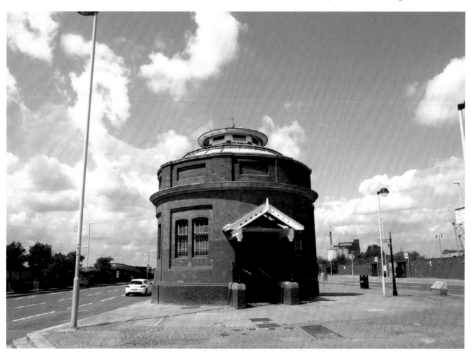

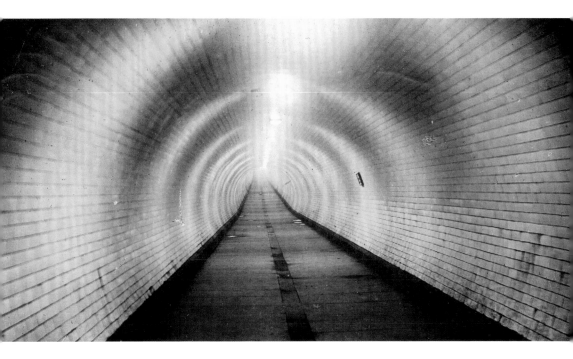

Inside the Woolwich Foot Tunnel

The tunnel was closed in 2010 due to structural weakness, but after being upgraded it has now reopened. The inside of the tunnel itself has changed little since it was built. As the modern image of the tunnel shows, it is a far from welcoming entrance and shows its age despite the upgrade that was carried out a few years ago.

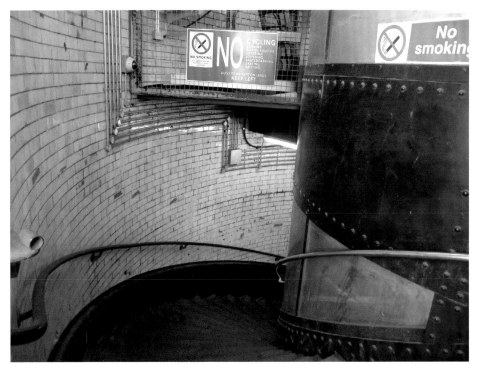

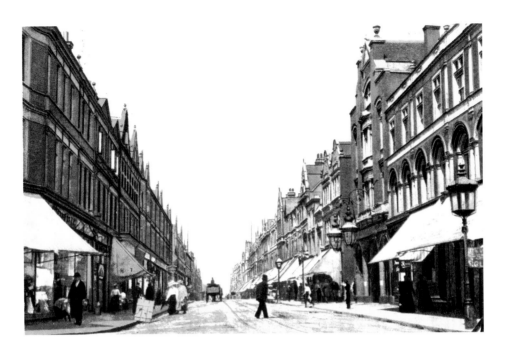

Powis Street Woolwich

Powis Street runs from the old Royal Arsenal gates in Beresford Square to the ferry. It must have been a very busy and important route in the past for those travelling to and from the Arsenal to the river crossing. The old image shows a wide road lined with old buildings, most of which were shops. This has not changed as the road is still a busy shopping centre, although much of it has now been closed to traffic and is pedestrianized. Trees have also been planted along the part of the road shown in the modern image.

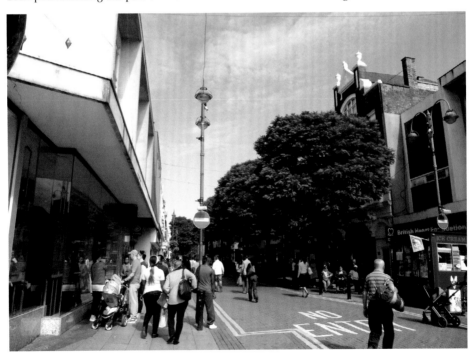

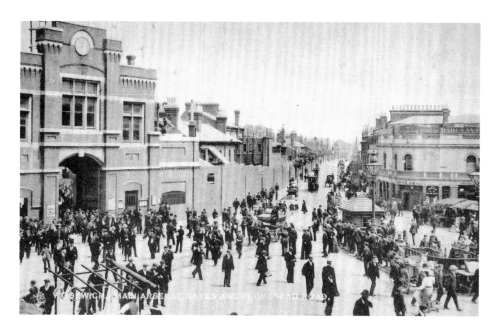

Woolwich Arsenal

The arsenal has origins going back to the seventh century but reached its peak during the First World War when it covered more than a 1,000 acres and employed over 80,000 people. In 1893, the Woolwich Arsenal football team turned professional. In 1910 they were taken over by Henry Norris, chairman of Fulham, and moved to Highbury. They have since moved again to the Emirates Stadium, but retain old connections with the cannon outside the ground (their nickname is the *Gunners* and they have a cannon on their badge). The Arsenal closed in 1967, and much of the site has been converted into homes or other uses. There is a Woolwich Arsenal station on the Dockland Light Railway. The Old Arsenal Gate House now stands alone in Beresford Square.

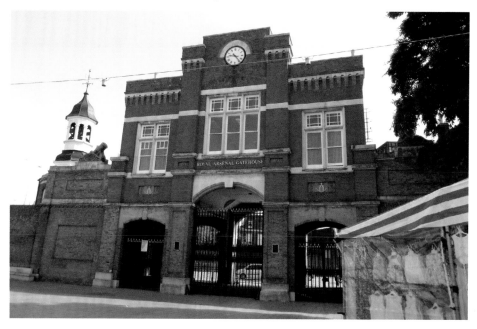

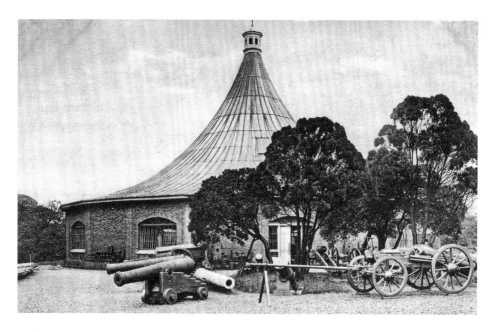

Military Woolwich

Along with the Arsenal, Woolwich has a long military history with barracks situated in the town for many years. The Rotunda, shown in the old image, is an artillery museum which began life in 1814 as a reception centre for the victorious heads of state after the Napoleonic War. It was originally a large tent in St James' Park. In 1820, a more permanent building was designed by John Nash on Woolwich Common. It is now rarely open, and its future seems to be in doubt. Another military artefact in the area is the large mortar shown in the modern image, which is placed on the corner of Repository Road and Artillery Place opposite the barracks.

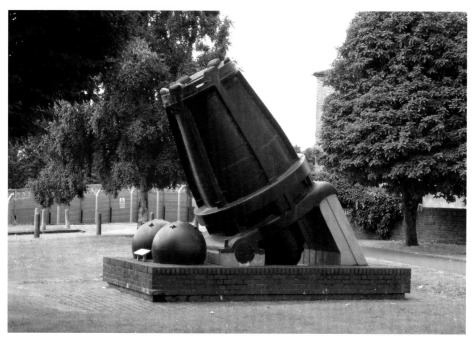

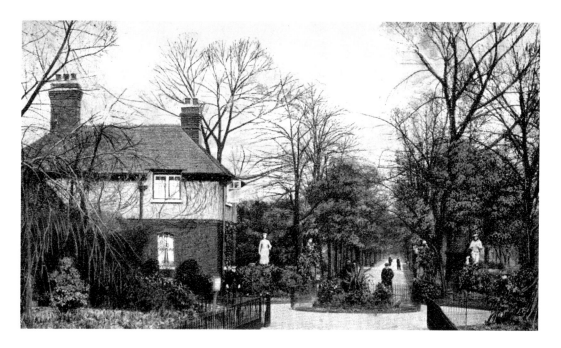

Royal Victoria Gardens Woolwich

The gardens at Woolwich have an interesting history for a park. Opened in the mid-nineteenth century as the Royal Pavilion Gardens by William Holland, they were a popular entertainment centre with circus acts, dancing and music that residents of London could reach by train and by boat. The gardens had financial problems, and Holland eventually escaped from the gardens in a hot air balloon after owing large amounts of money. The gardens fell into disrepair until reopened as the Royal Victoria Gardens in 1890. There retains a docklands connection as it contains a large steam hammer that came from a ship repair shop at the Royal Albert Dock.

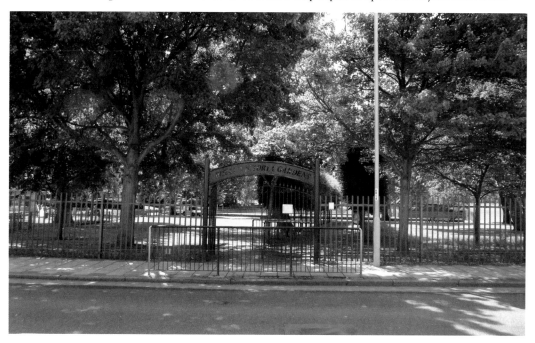

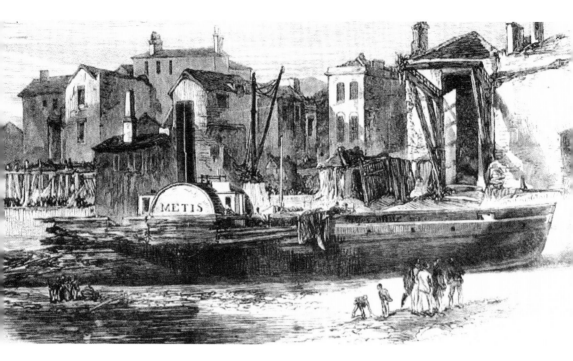

A Wreck at Woolwich

The large volume of traffic on the river Thames in the nineteenth century often led to accidents. The old print shows the steamship Metis, a paddle steamer that collided with another ship in 1867. It is shown on the river bank at Woolwich. The modern image shows the river at Woolwich looking towards London. It also shows the Thames barrier, Greenwich Peninsula, the O2 and the buildings at Canary Wharf, with some of the buildings in central London visible in the distance.

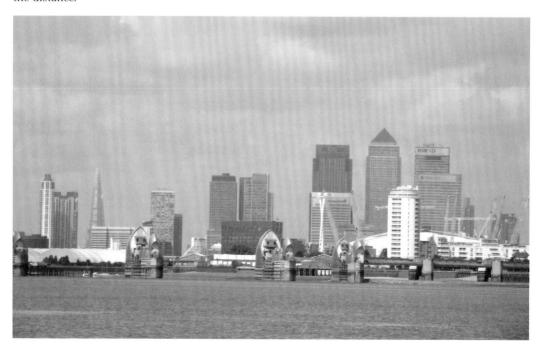

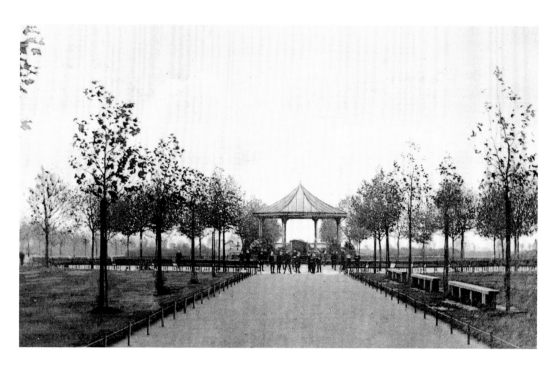

Becton Park

Beckton Park is one of the few parks with its own railway station outside central London. The park opened in 1903, although the area was not well populated at the time. It consisted mainly of Marsh land. The area's main claim to fame was the gasworks. The name Beckton actually came from Simon Adam Beck, the governor of the works. Much of the area was covered in prefab housing after the war, but the houses in the modern image are part of the large new estate built after 1981.

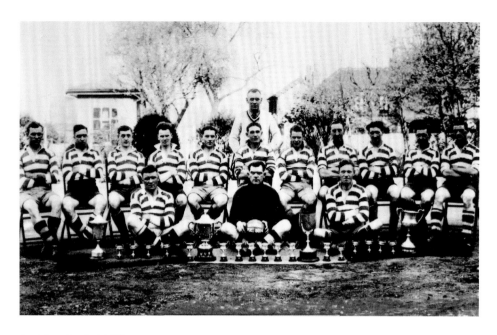

Beckton Gaslight FC

The Beckton Gasworks opened in 1870. It was given its name by its governor, and was described as one of the largest gas works in the world. It supplied much of London, north of the river, with gas. It was nationalised in 1949 and closed with the coming of North Sea Gas in the late 1960s. The spoil from the works were piled high into what became known as Beckton Alps. In keeping with the name the site was used as a dry ski slope from 1989–2001. The old image shows the company football team. Unlike other company teams from docklands, the gasworks team did not progress to the higher reaches of the game. The modern image shows the remaining frame of the gas holder at the works taken from above the Beckton sewage works. Since the works closed they have been used as a set for a number of high-budget films.

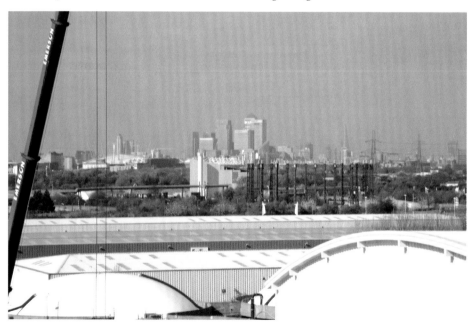

St Cedds Church

There seems to have been some doubt as to the position of the original St Cedds church. From 1903–14, it was described as a mission church of St Andrews Plaistow. The old image shows what is described as an open air service at St Cedds, but gives no location. I would imagine that there was such open air events to try and attract those working and living in Docklands who may not have attended a regular church service. There was, it seems, a permanent church building built in 1936 in Becton Road. There does not seem to be any sign of a church in the road now, and I have read reports of the building being badly damaged by vandalism in recent years, so am unsure if the church is still in existence.

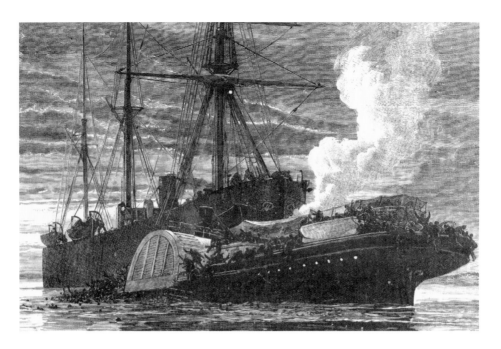

The *Princess Alice* Disaster

The *Princess Alice* was originally named the PS *Bute* but was renamed in 1867. It was one of the many steamers that ran a passenger service from London down to places such as Gravesend where there were well attended pleasure gardens. For many Londoners, a day trip downriver would be the only holiday they would have. The steamers were often crowded with trippers, and as tickets could be used on a number of the craft owned by the same company, there was never clear knowledge of how many passengers the boats were carrying. In September 1878, the *Princess Alice* collided with the *Bywell Castle*, a collier and a much larger ship. The collision took place on the river near the sewerage works at Beckton. The number of people who died was reportedly 650. It was the worst accident to ever occur on the Thames. The old print is a contemporary image of the incident. The modern image was taken from above the Beckton Sewage Works showing the river looking towards Woolwich where the incident occurred.

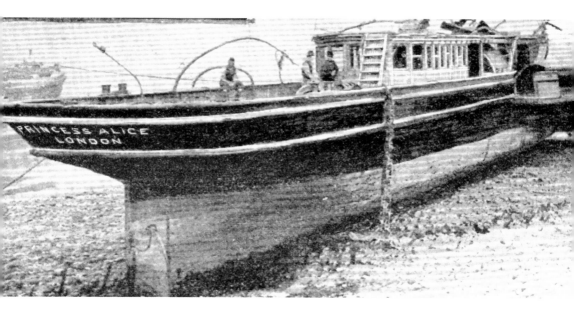

The *Princess Alice* Disaster

The old print shows the wreck of the Princess Alice after it was raised. Many bodies were found inside the wreck. When the accident occurred it was unusual for many of the working-class passengers to be able to swim. Even if they could, the heavy clothes they wore hindered them. The water in which the accident took place was also very unhealthy being that it was close to the outfall of the sewage works at Beckton. Many of the survivors, and a number of bodies, were taken to the small village of Creekmouth on Barking Creek. The school building was used as a temporary mortuary. The village no longer exists as the area has now been turned over to industry. The last houses vanished some years ago, and only the old public house remains. The modern image shows a memorial plaque close to where the village once stood on some open ground near the flood barrier at the mouth of Barking Creek.

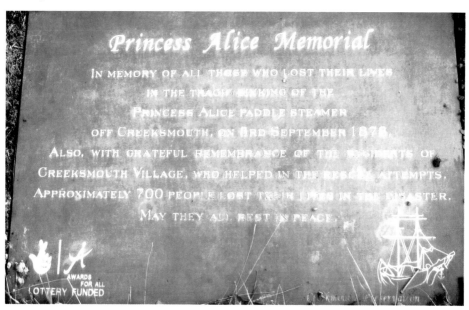

Tilbury Dock

The work of the London Docks moved to Tilbury when they closed in the 1960s and 1970s. It comes as a surprise then, that the docks at Tilbury on the north bank of the Thames, 25 miles from London Bridge, have existed since the late nineteenth century. The docks were expanded in the 1960s after the London Docks began to close. As well as handling goods, most of which now arrives in containers, Tilbury has also been a passenger terminal for many years. Many of the '£10 Poms', those who emigrated to Australia under the government scheme, left from Tilbury. It was also where many of the first immigrants from the West Indies arrived in Britain. The old image shows the large ships that the docks could deal with. The modern image shows how much of the work at Tilbury is in handling goods in containers.

Acknowledgements

I would like to thank Jeanette Newton for the use of photos of her great-grandfather. Tony Oliver for the use of his photos.

Other Amberley Books by Michael Foley
Havering Through Time
Barking and Dagenham Through Time
London Through Time
The East End of London Through Time
Essex at War Through Time Essex at War From Old Photographs
Essex Through Time
Martello Towers

London: Portrait of a City

Allan Hailstone

With over 120 unique images of people and places in London in
the fifties and sixties, *London: Portrait of a City 1950–1962* paints
a picture of England's multifaceted capital in a decade of great
change and development. From grand monuments to innocuous
street corners, famous faces to passers-by, this selection of evocative
photographs captures the very essence of London life in the
mid-twentieth century.

978 1 4456 3587 3
128 pages

Available from all good bookshops or order direct
from our website www.amberleybooks.com